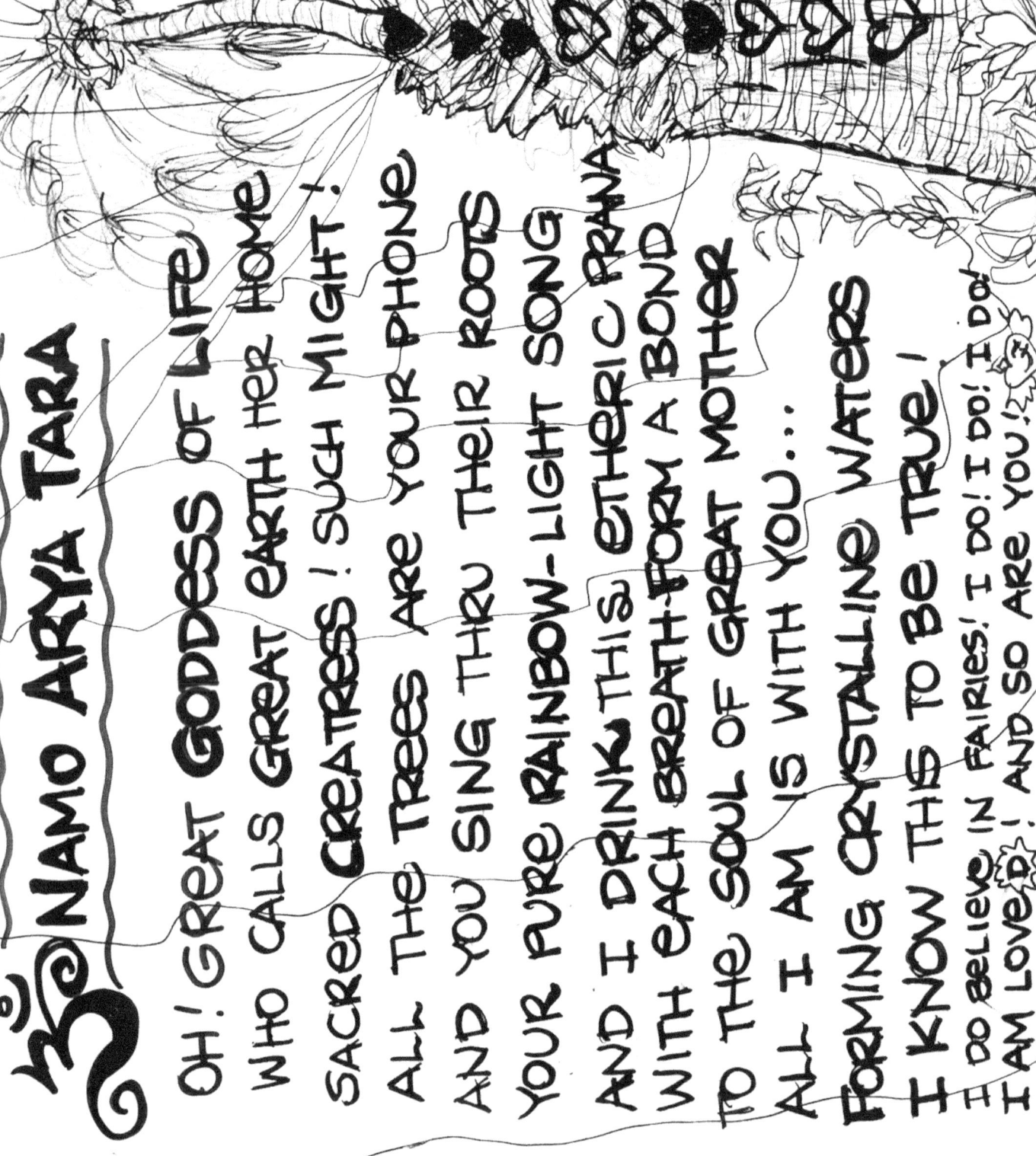

ॐ NAMO ARYA TARA

OH! GREAT GODDESS OF LIFE
WHO CALLS GREAT EARTH HER HOME
SACRED CREATRESS! SUCH MIGHT!
ALL THE TREES ARE YOUR PHONE
AND YOU SING THRU THEIR ROOTS
YOUR PURE RAINBOW-LIGHT SONG
AND I DRINK THIS ETHERIC PRANA
WITH EACH BREATH FORM A BOND
TO THE SOUL OF GREAT MOTHER
ALL I AM IS WITH YOU...
FORMING CRYSTALLINE WATERS
I KNOW THIS TO BE TRUE!
I DO BELIEVE IN FAIRIES! I DO! I DO! I DO!
I AM LOVED! AND SO ARE YOU!

♡ MY NAME IS ♡ CHRISTA GALACTICA ⚡
AND I HAVE A FAIRY SPECIAL GIFT ♪...

♪ I HEAR THE WHISPERS FROM THE TREES ~
TEACHING ME HOW TO LIVE ~~~

♪ I TAKE THEIR LESSONS INTO MY HEART ♪
THEIR SONGS INTO MY HEAD

♪ I 'SEE' THEIR SWIRLING ENERGY FIELDS
DANCING AROUND THEIR BEDS

♪ I FEEL THEIR MAGICAL PROPERTIES~
SHINING BIG & BRIGHT

♪ I LOVE THE JOY THEY SHARE WITH ME
IT FILLS ME WITH DELIGHT!

♪ THEY HAVE ASKED ME NOW TO BE THEIR VOICE
MY TIMING IS NOW RIPE...

♡ AND SO I SIT WITH MY TREE FRIENDS ~
MY FEATHER PEN ~ AND I WRITE!

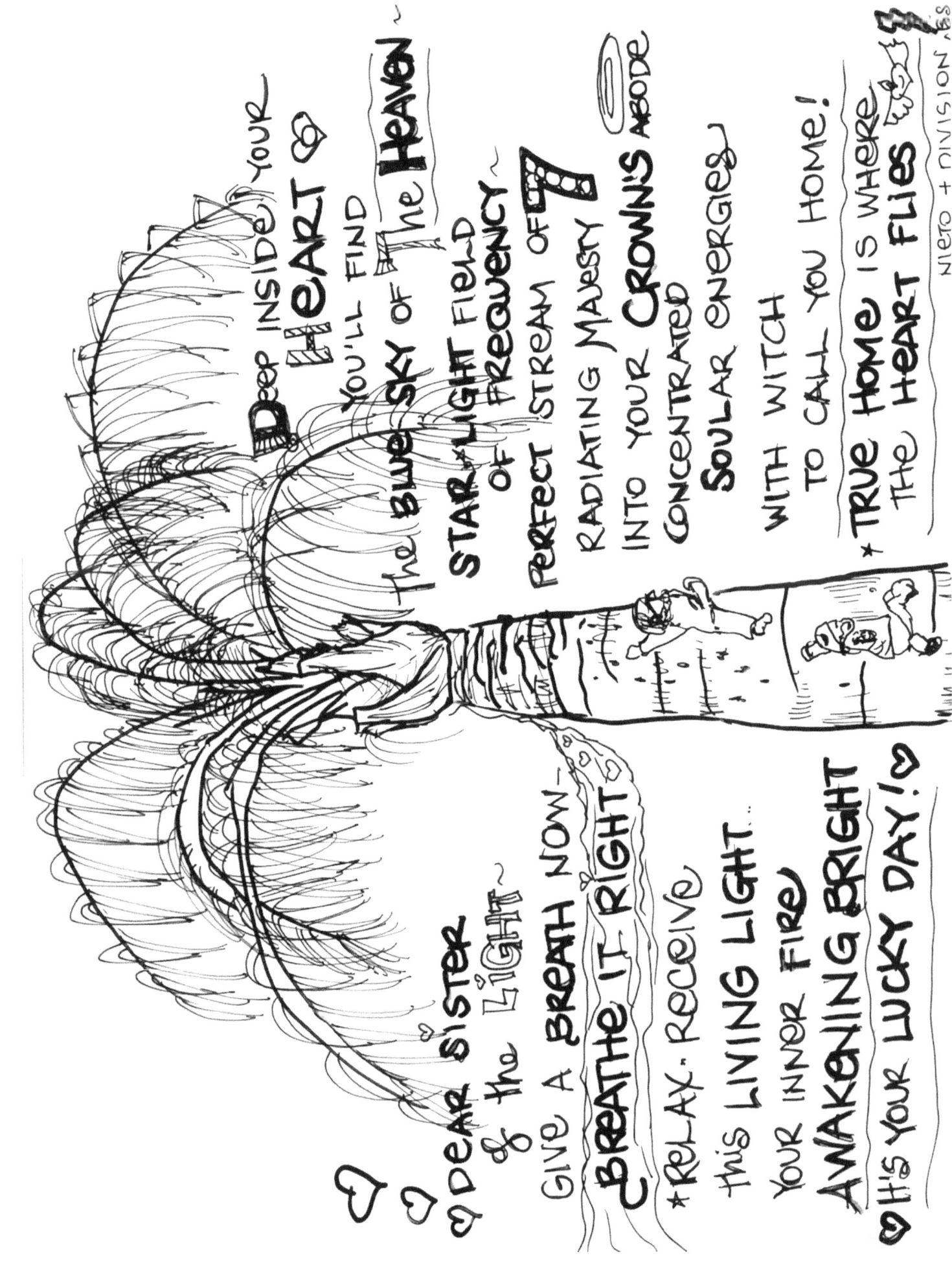

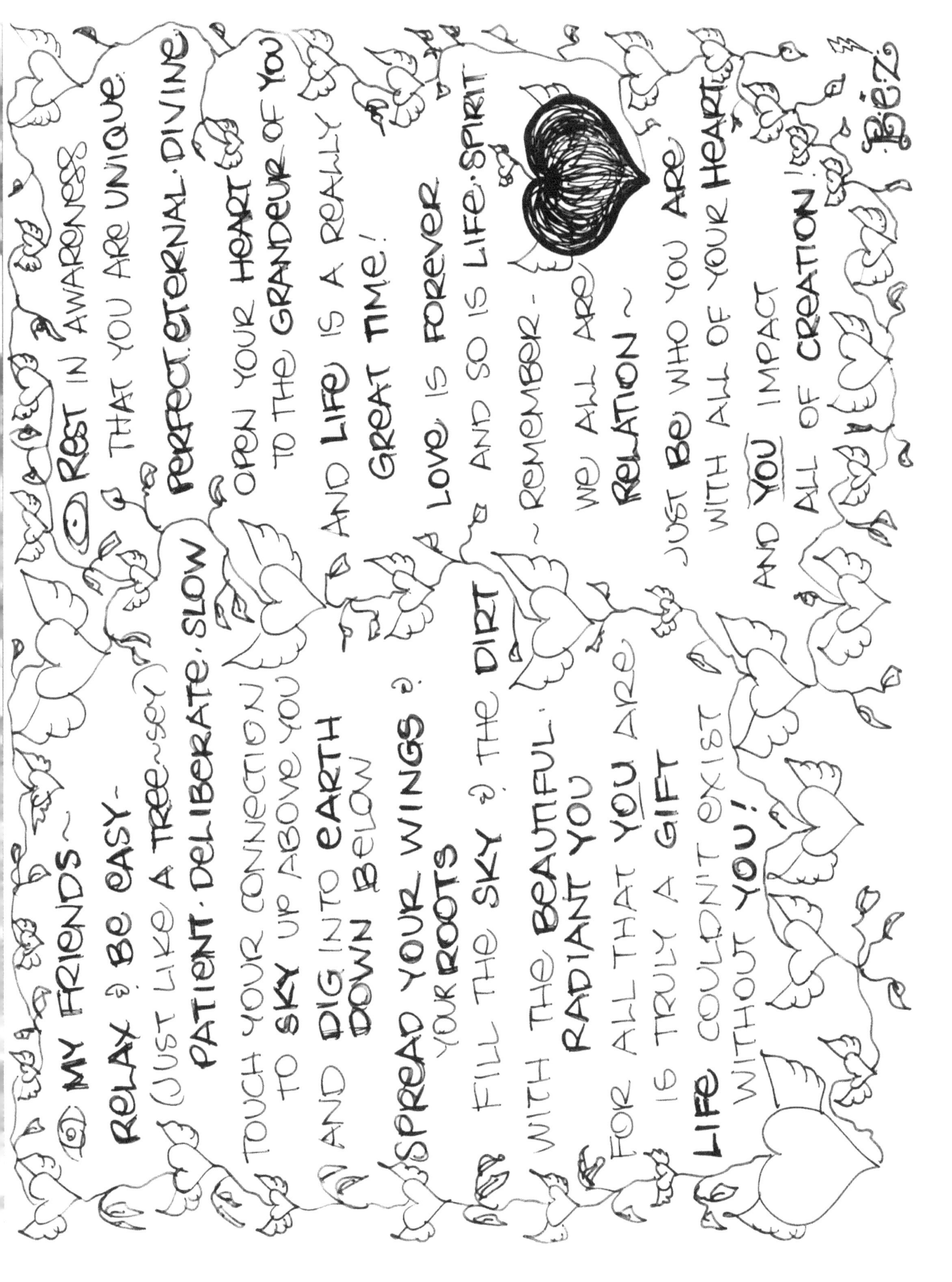

☉ MY FRIENDS ~

RELAX & BE EASY ~
(JUST LIKE A TREE ~ SO)
PATIENT. DELIBERATE. SLOW

☉ REST IN AWARENESS
THAT YOU ARE UNIQUE.
PERFECT. ETERNAL. DIVINE

OPEN YOUR HEART
TO THE GRANDEUR OF YOU

TOUCH YOUR CONNECTION
TO SKY UP ABOVE YOU
AND DIG INTO EARTH
DOWN BELOW

AND LIFE IS A REALLY
GREAT TIME!

SPREAD YOUR WINGS &
YOUR ROOTS

LOVE IS FOREVER
AND SO IS LIFE. SPIRIT

FILL THE SKY & THE DIRT
WITH THE BEAUTIFUL.
RADIANT YOU

~ REMEMBER ~
WE ALL ARE
RELATION ~

FOR ALL THAT YOU ARE
IS TRULY A GIFT

JUST BE WHO YOU ARE
WITH ALL OF YOUR HEART♡
AND YOU IMPACT
ALL OF CREATION!

LIFE COULDN'T EXIST
WITHOUT YOU!

Bez.

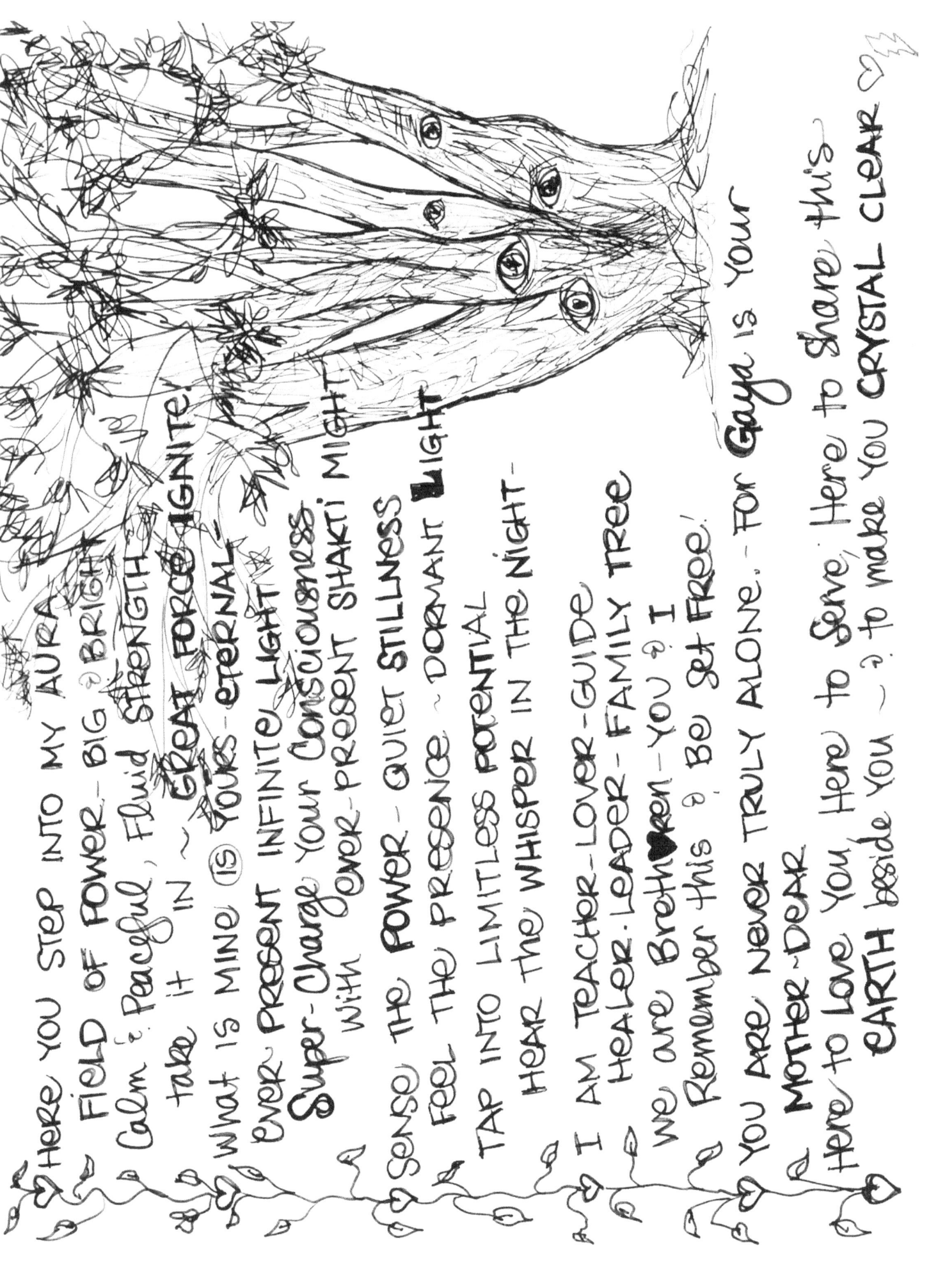

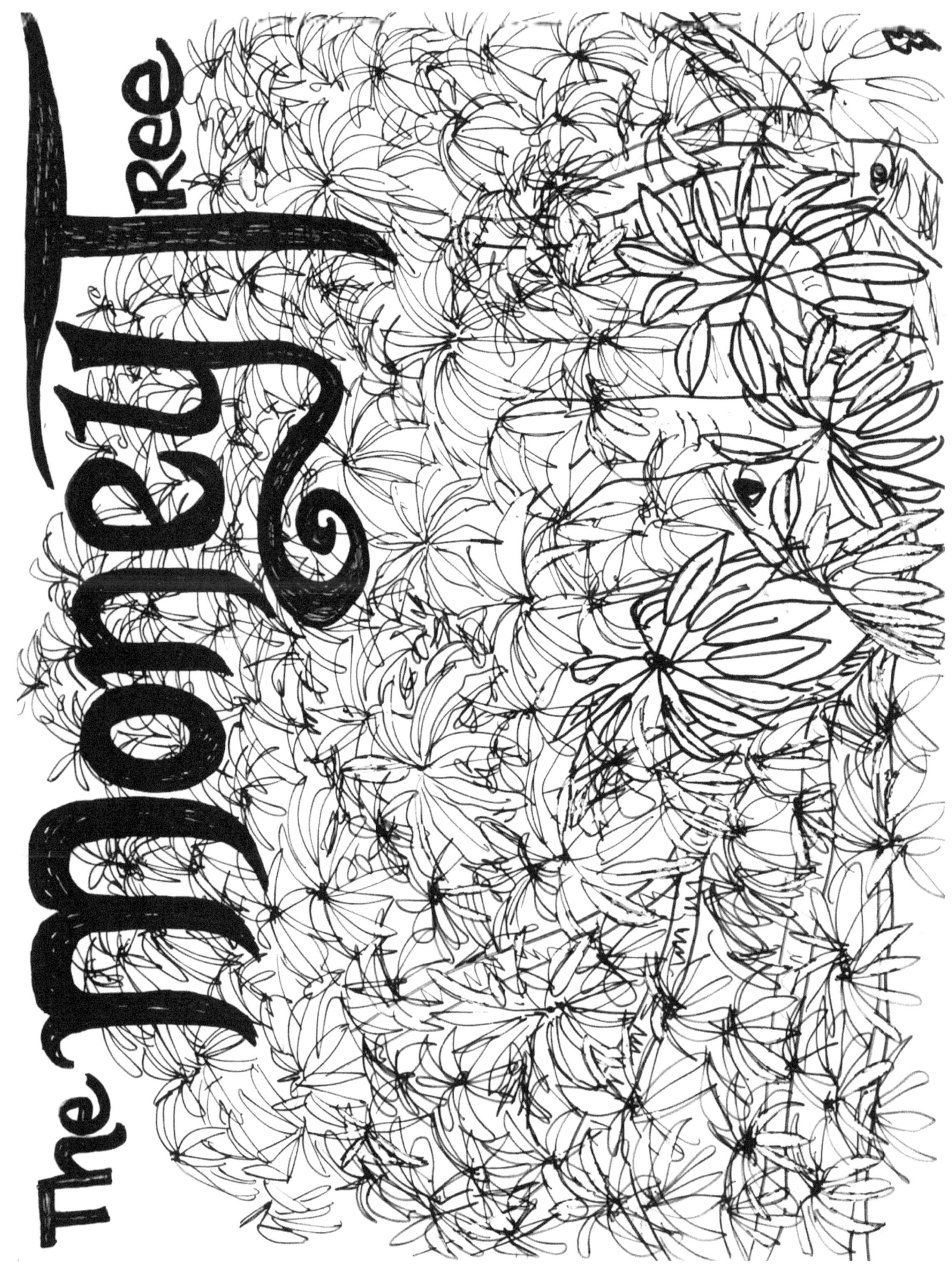

♡ MY LIFE FORCE FLOWS ABUNDANTLY — Underground & Everywhere
ALL AROUND — WITHIN & AROUND YOU
 ♡ Can You Sense it in the AIR?
 That You BREATHE —
 ♡ Breathe it IN — So GREAT to Share
 Breathe it OUT — Now THAT'S QUITE FAIR

♡ MIRROR, MIRROR ON A TREE —
 We See You — Can You See Me?
 ♡ My eyes are OPEN ~ just to Be
 Open YOUR HEART & MAKE BELIEVE —
 I WISH & HOPE & DREAM AWAKE
 We can be FRIENDS — give & take *BREATH* IN & OUT
 ♡ like a SHAKE — of the HANDS — or a WAVE
 of a LEAF in the Breeze
 thru the Trees
 that I AM...

♡ I BELIEVE — I AM a BELIEVER —
 I See the Value & the TREASURE —
 ♡ I treasure the Gifts of this WONDERFUL LIFE
 I Share them WITH YOU — NOW & FOREVER! ♡ Money Tree ♡

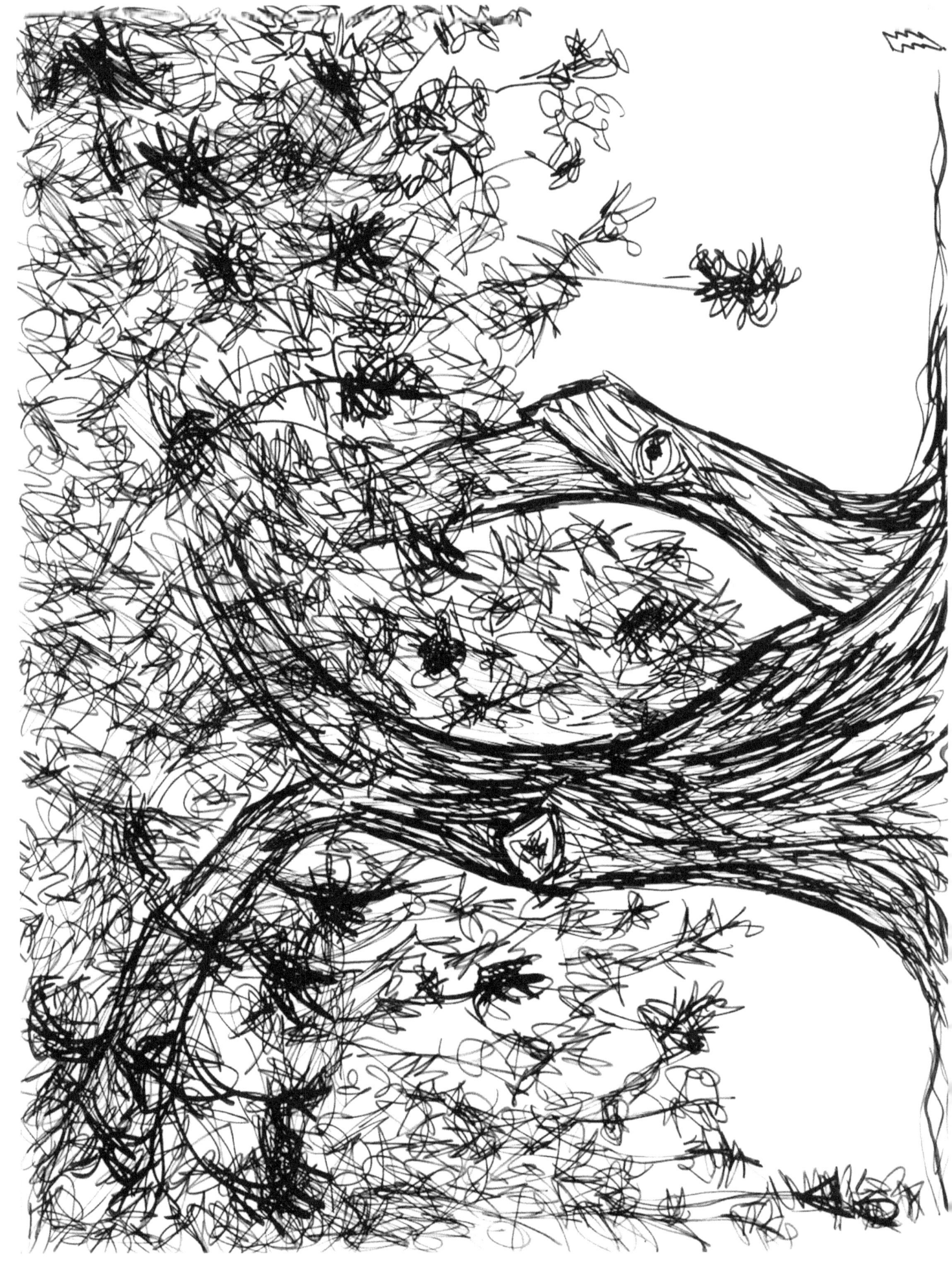

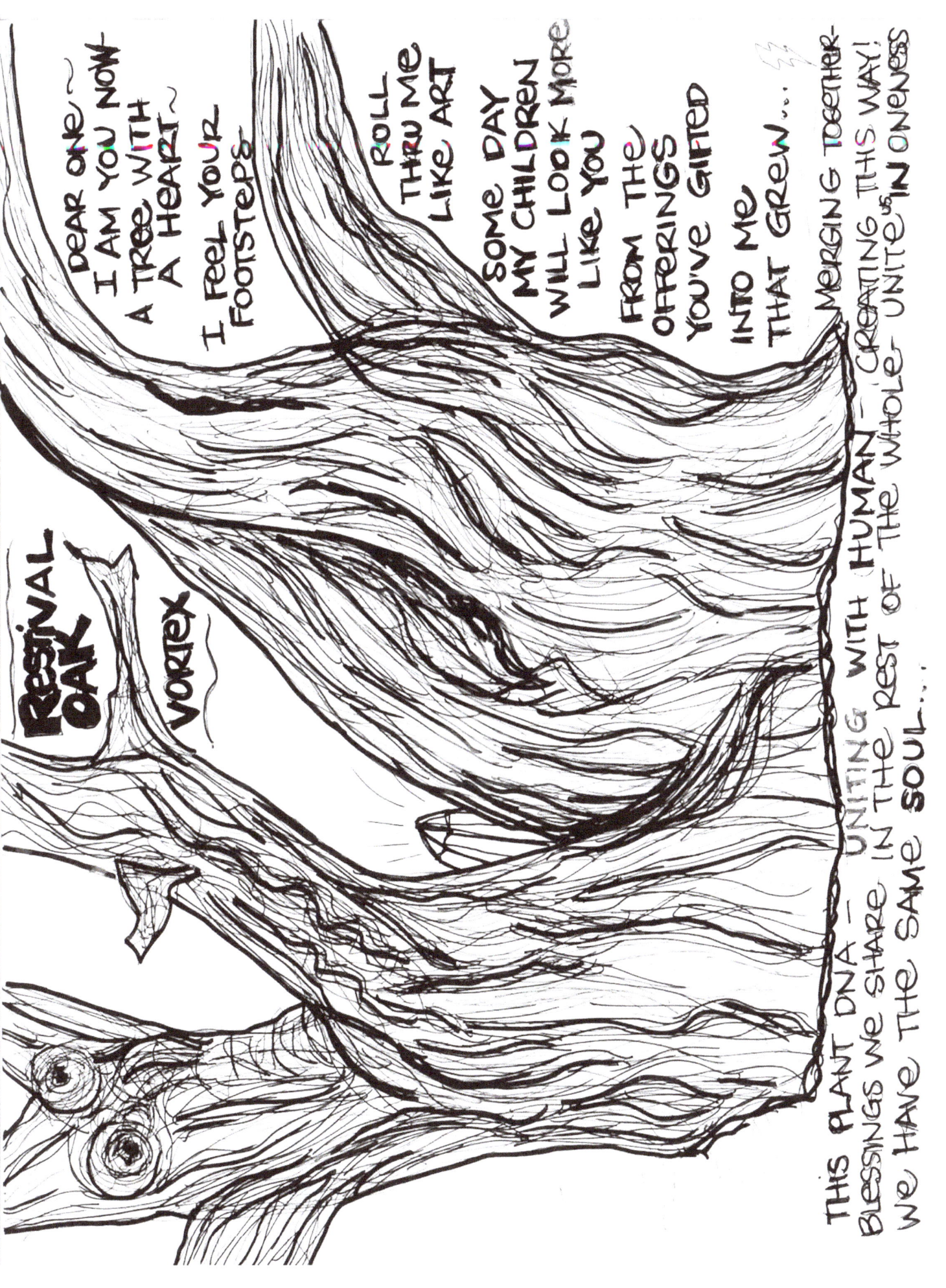

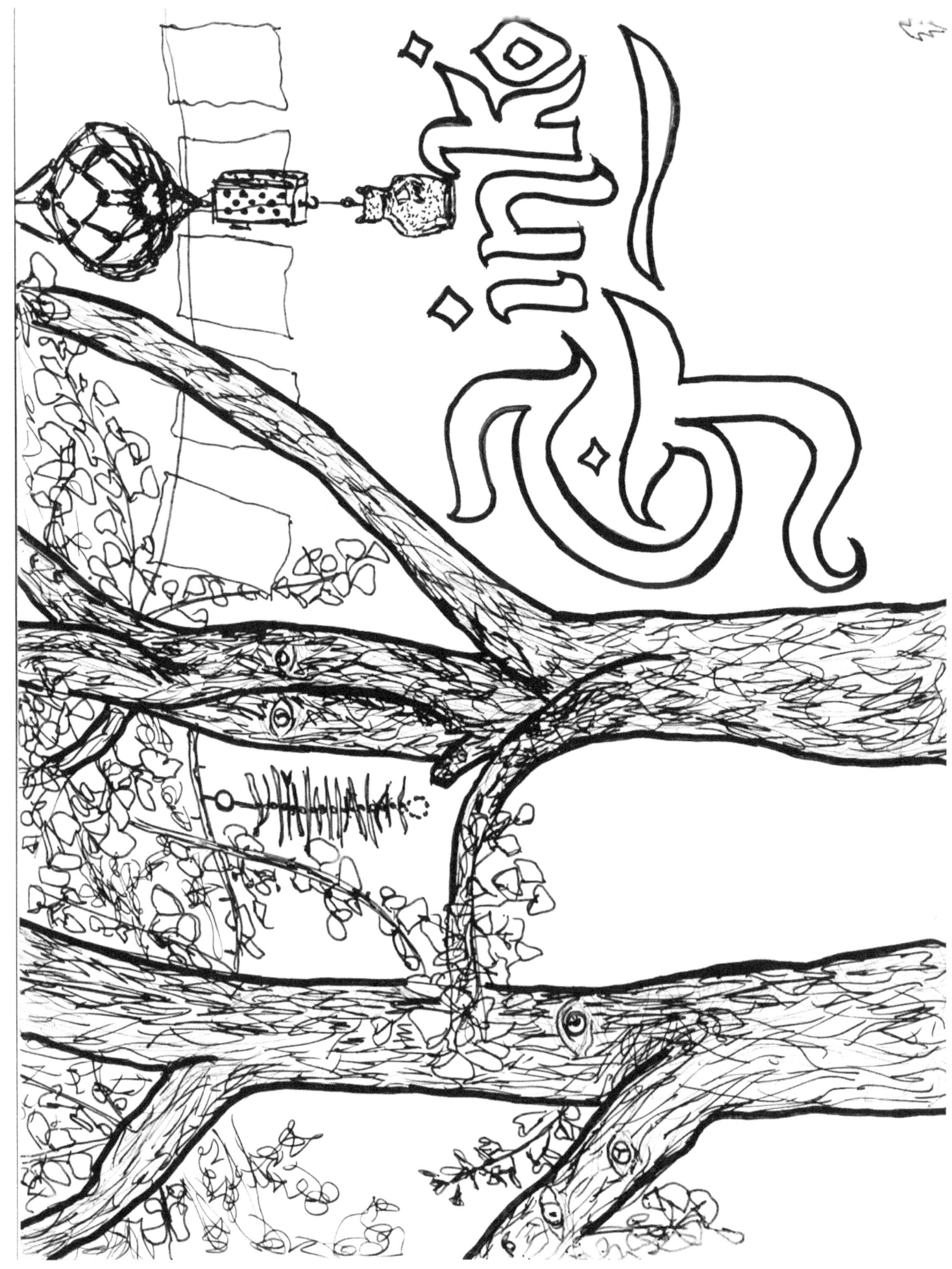

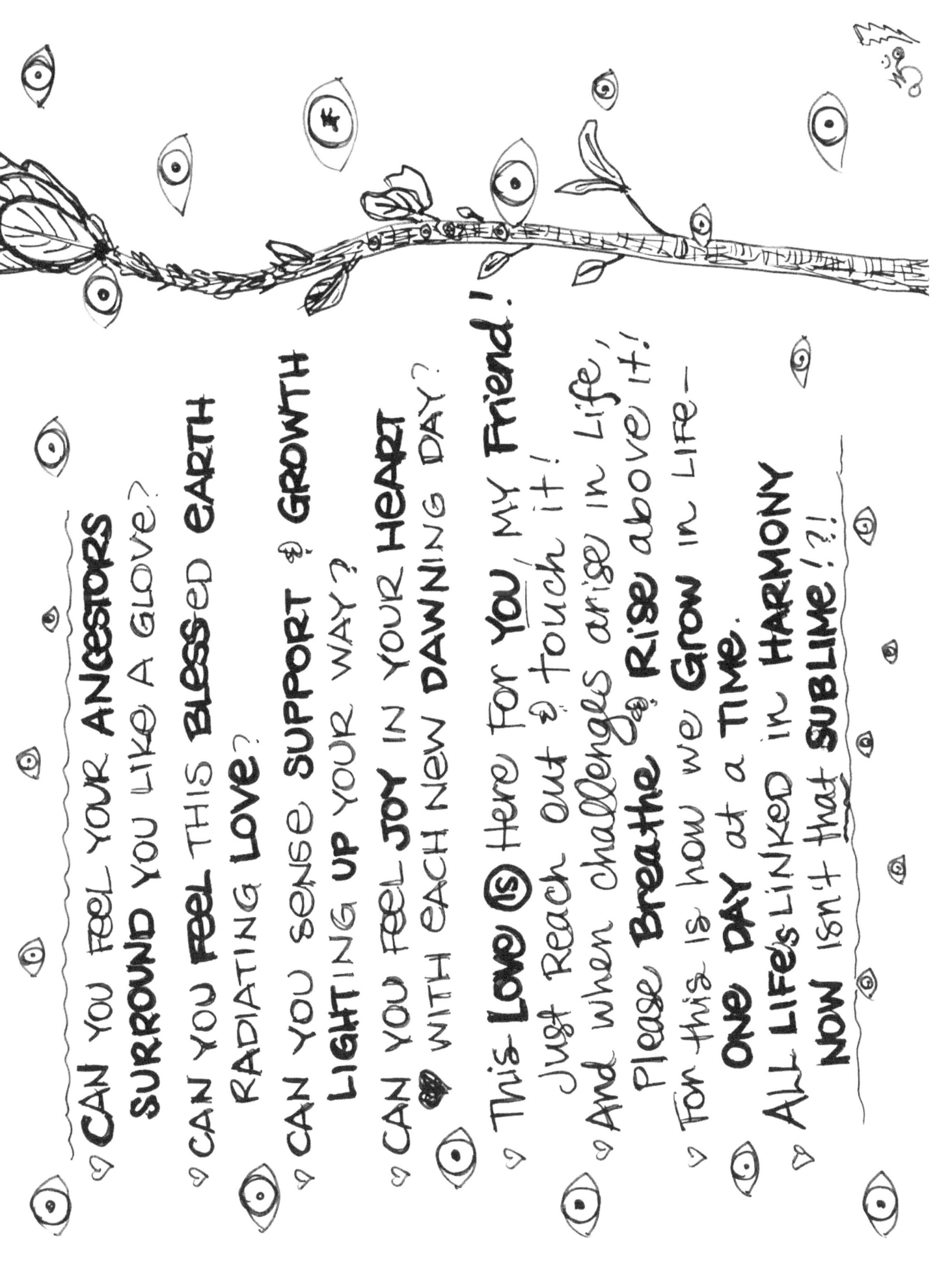

♡ CAN YOU FEEL YOUR ANCESTORS SURROUND YOU LIKE A GLOVE?

♡ CAN YOU FEEL THIS BLESSED EARTH RADIATING LOVE?

♡ CAN YOU SENSE SUPPORT & GROWTH LIGHTING UP YOUR WAY?

♡ CAN YOU FEEL JOY IN YOUR HEART WITH EACH NEW DAWNING DAY?

♡ This Love IS Here for YOU, My Friend! Just Reach out & touch it!

♡ And when challenges arise in Life, Please Breathe, Rise above it!

♡ For this is how we Grow in Life — ONE DAY at a TIME.

♡ ALL LIFE's LINKED IN HARMONY NOW isn't that SUBLIME!?!

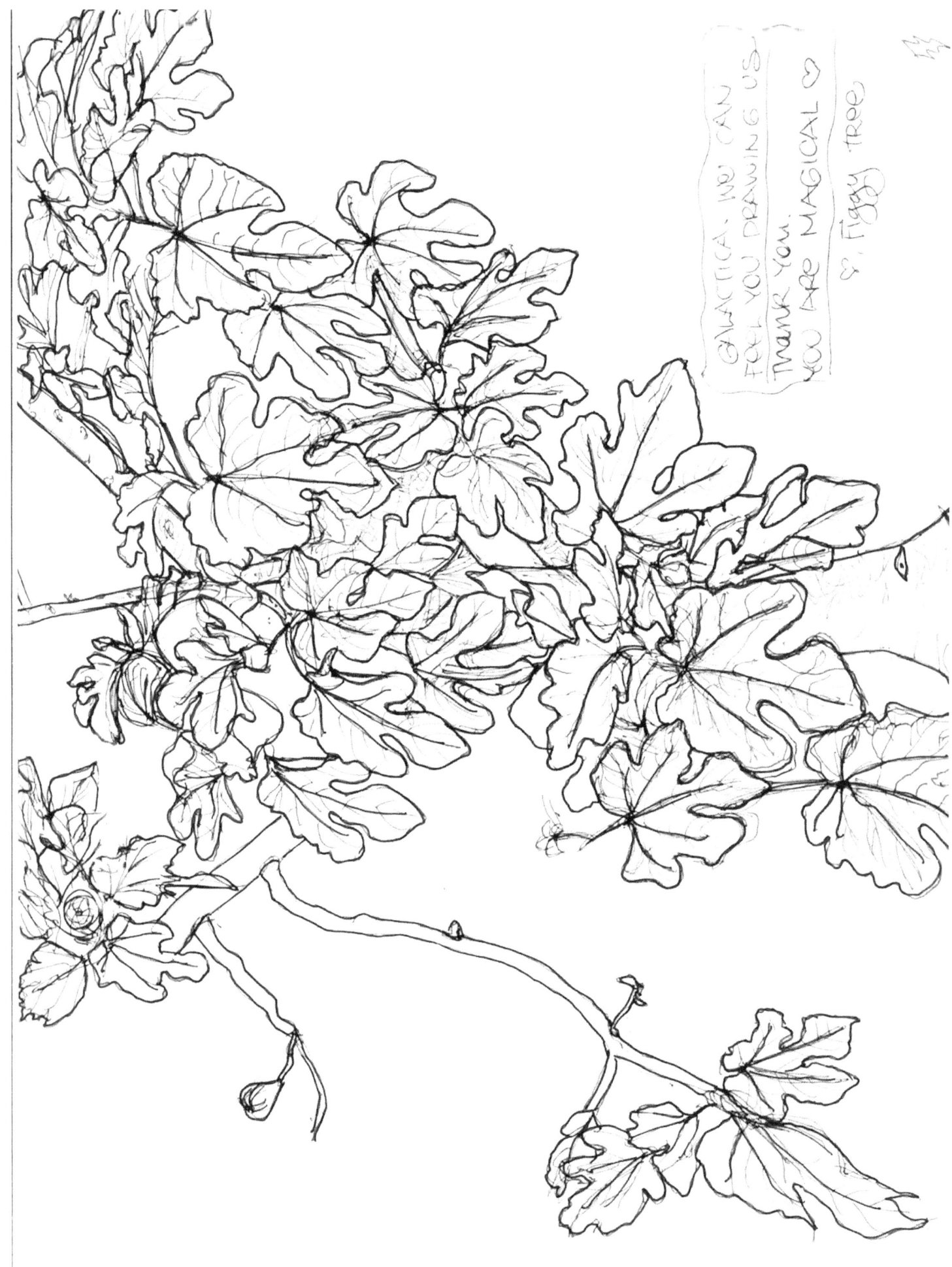

MY FIGGY TREE

I HEAR YOUR **VOICE**
INSIDE ME

MY TREE FRIEND~
NEIGHBOR DEAR

IN **GRATEFULLNESS**~YOU
FILL ME UP

YOUR RESONANCES
CLEAR

I FEEL YOUR **WAVES**
ABUNDANTLY

A FIELD OF
LIVING LOVE

I **BLESS** YOUR DEAR
SWEET ENERGIES

AND **THANK YOU**
FIGGY DOVE

YOUR FRUITS~THEY ARE **WITHIN ME**
NOW I AM YOU INSIDE

YOUR **GRATITUDE** IS IN ME TOO
PLEASE TAKE ME FOR A RIDE

INTO YOUR DEEP **RICH SOIL**~
YOUR **ROOTS** WITHIN THE EARTH

AND GRAB THIS LIFE
WITH ALL WE'VE **GOD**
AND **WAVE** AT ALL THE **BIRDS**

HEY FAMILY! FAMILY! OVER HERE!
COME CHECK OUT ALL MY **GIFTS**!

I'VE MADE THEM **FREELY**~JUST BECAUSE
IT'S HOW I **CHOOSE** TO LIVE
PLEASE HAVE A BITE
AND **BECOME ME**
FOR NOW WE 2 ARE 1.
THE **ALCHEMY** IS SO EASY 'COZ~
THIS FIGGY KNOWS THE **SUN**.

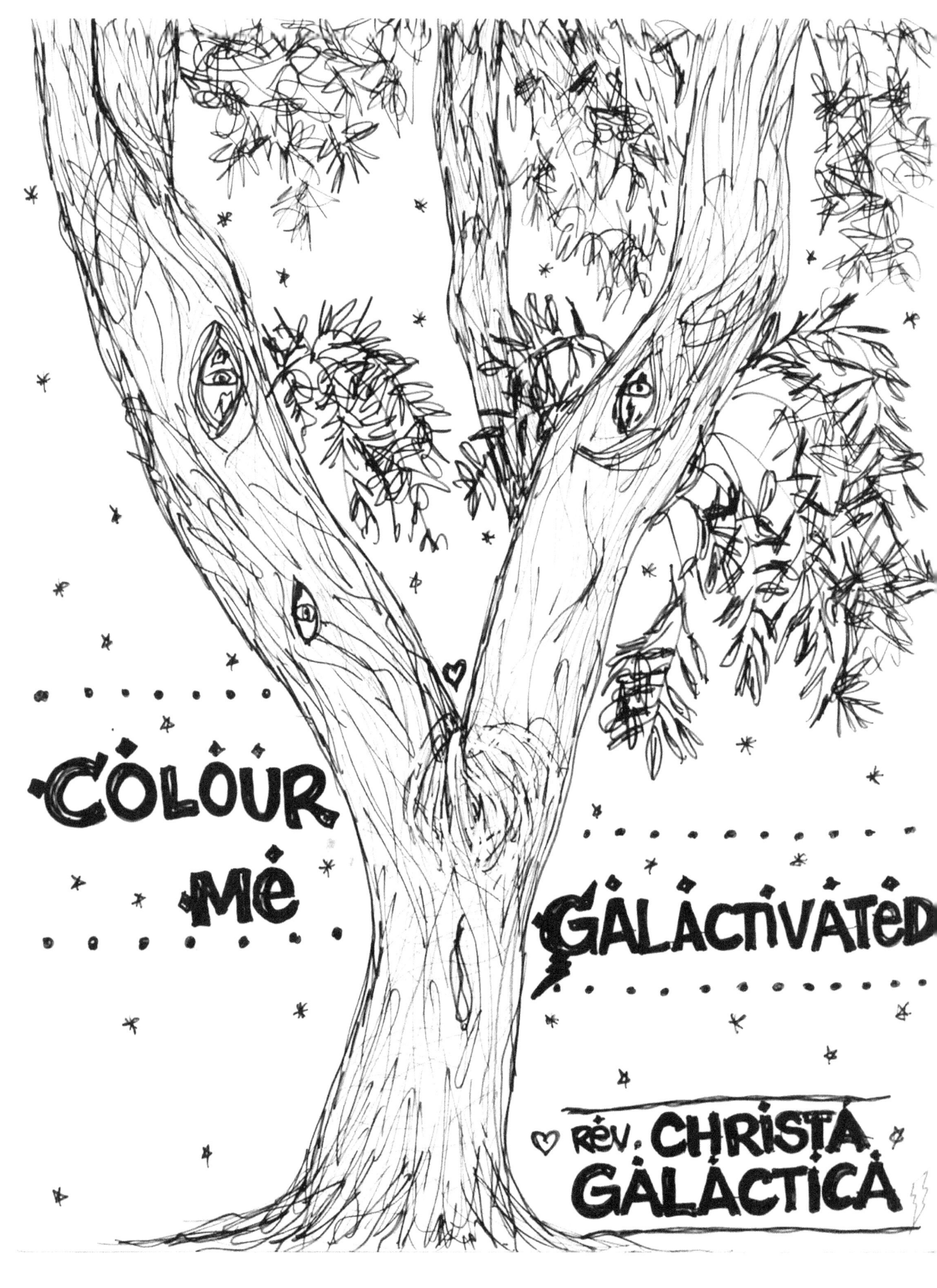

...LISTEN...

IN ORDER TO SHIFT YOUR BEING
TO A PERSON OF THE LIGHT
YOU MUST BREATHE THRU YOUR AWARENESS
 OF THE THINGS WHICH 'AREN'T QUITE RIGHT'
BEGIN TO SEE ~ & FEEL ~ & KNOW ~
THE TIMES WHEN ~ 'YOU DON'T BREATHE' ~
AND BEGIN. AGAIN. 👁 RIGHT HERE. & NOW
TO SIMPLY... JUST... RECEIVE!!!
~ ~ BREATHE... ~ RECEIVE... ~ RECEIVE & LET GO ~
 ALLOW 'WHAT IS' TO BE ~ (THAT WHICH IT BEE...)
IT IS WHAT IT IS... 👁 I AM WHAT I AM...
ALL JUST (IS) (IS) (IS)... WHAT (IS) IT I BELIEVE?...

THINK AGAIN, DEAR ONE ~
 PLANT A SEED OF NEW THOUGHT ~
 SO IT MAY PROSPER, GROW, & THRIVE...

SMILE IN YOUR HEART AS YOU RELAX & LET GO
LET THE LIGHT WITHIN YOU CRYSTALLIZE!
 ~ COME ~ ~ ALIVE! ~
WHAT I GIVE OFF AS A TREE FRIEND OF YOURS
IS THE MAGICAL BREATH OF THE EARTH
BIG MAMA BENEATH ME
 WITH MY STREAM OF PURE LIGHT
UNIFY TO SUPPORT YOUR [RE]-BIRTH
SO, DRINK IN MY NECTAR, GREAT SISTER-IN-LOVE
FOR TOGETHER, WE ARE THE ONE!
BEGIN HERE & NOW - STRETCH YOUR ROOTS INTO MINE
DRINK MY LIGHT ~ YOUR BIRTH IS ♥♥♥! NOW DONE!

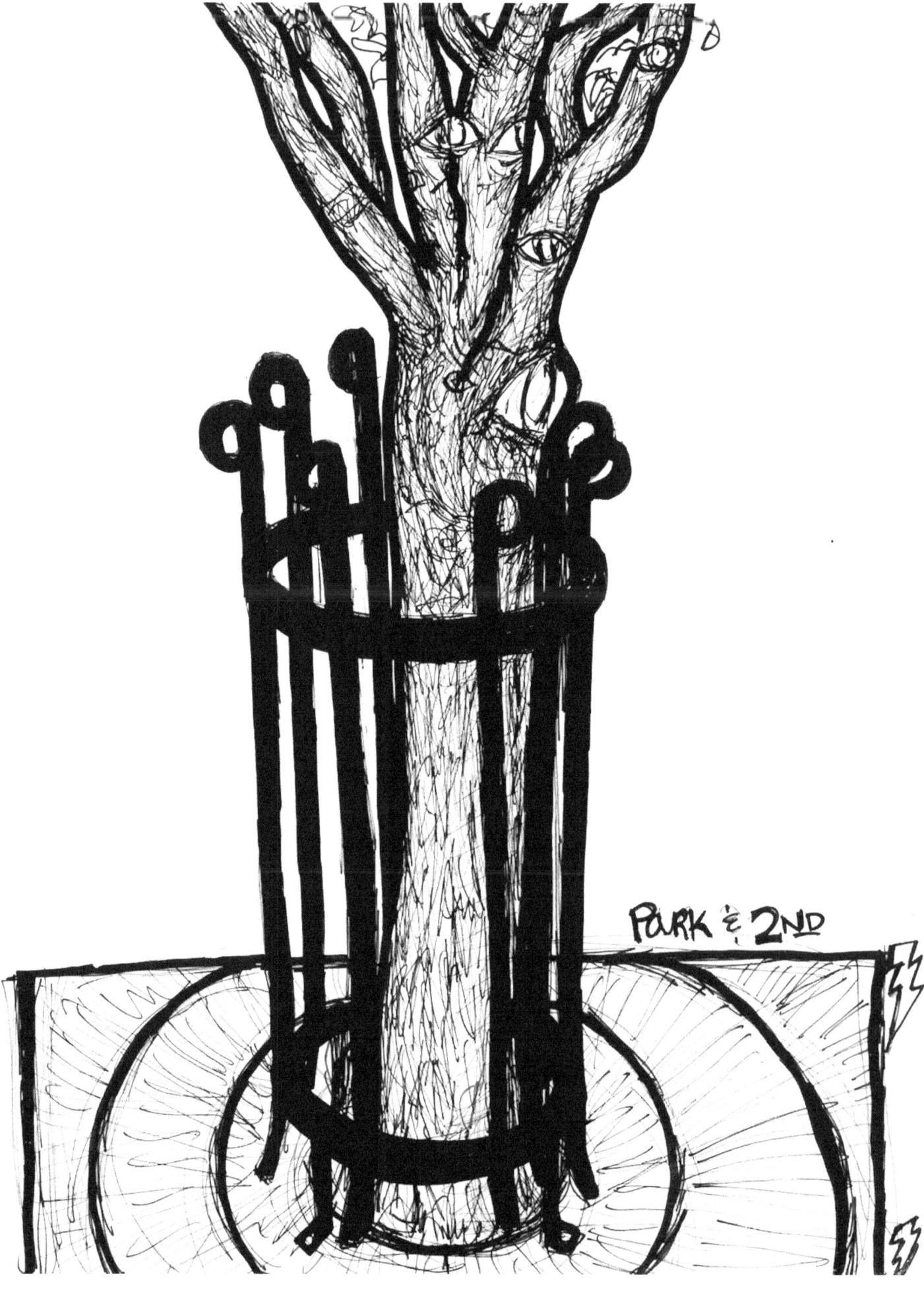

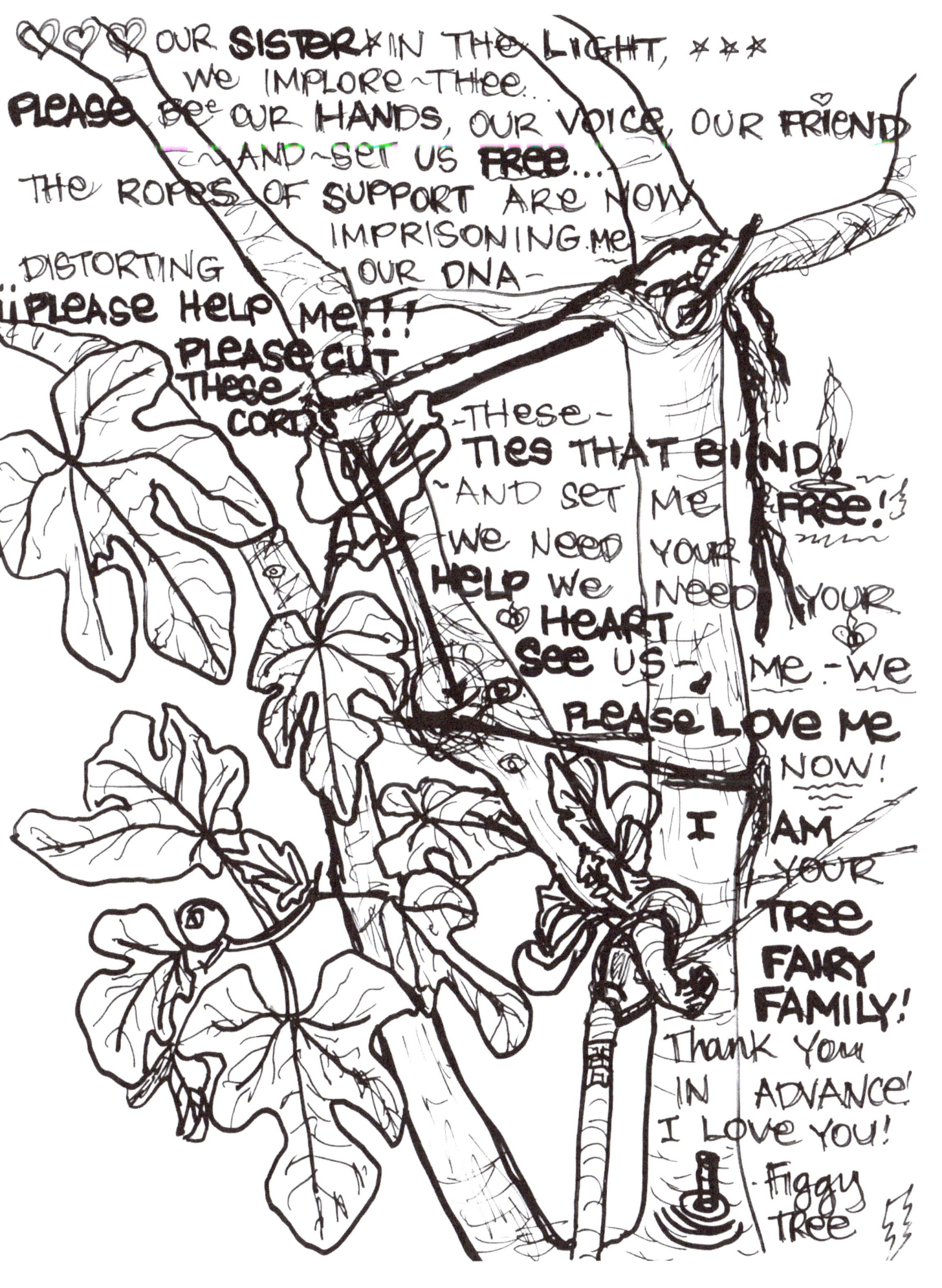

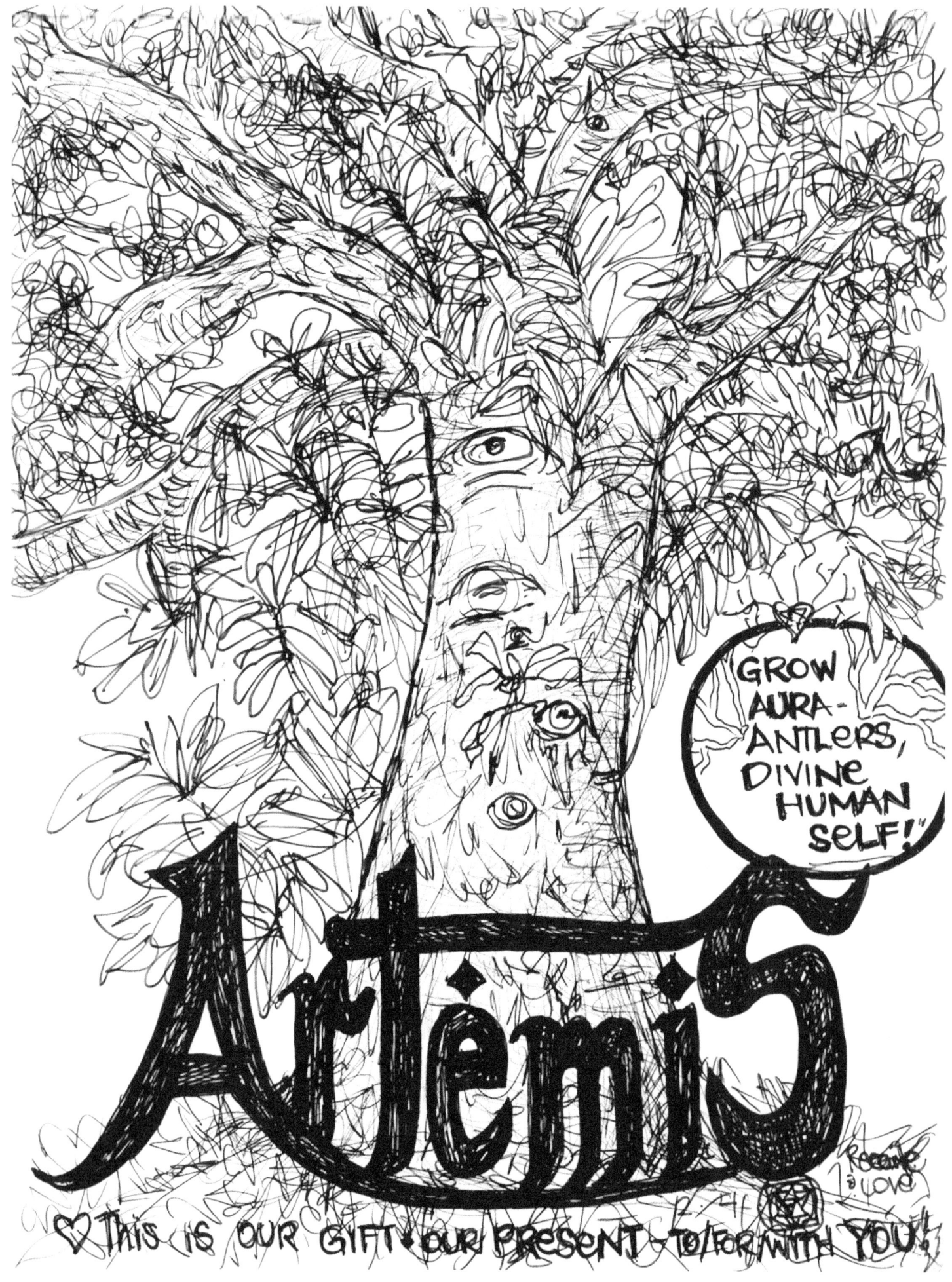

There is a HEART
 beating Inside ~ And if you Listen, closely ~
 It sounds like a DRUM...
The BEAT of the EARTH
 Pulsing WITHIN
 Unites us together
 And we ARE ALL ONE!

Can you Feel the Whispers. the Tingles. the Pulses.
 the Vibrations ~ Rippling thru Your Root?

Can You Feel the Song. the Dance. the torque.
 the SPIN ~ or are YOU WEARING BOOTS?

FOR SHOES, MY FRIEND, BLOCK the FLOW of the
 BEAT ~ & Cause YOUR SOLES to BLINDNESS
and we, MY FRIENDS, Sing a Symphony of LOVE ~
 Dedicated to YOU ~ YOUR HIGHNESS!

Can you BELIEVE we COULD BE ONE ~
 YOU ARE, IN FACT, A TREE!
You Are what you eat ~ the fruits of this LIFE,
 all DIFFERENT parts of the "We"!
So, KICK off those SHOES,
 put your feet in the sand, the water, the Dirt,
 & this EARTH!
Listen thru YOUR SOLES, prepare to EXPAND,
 & Relax. BREATHE. ENJOY ~ YOUR RE-BIRTH ♡

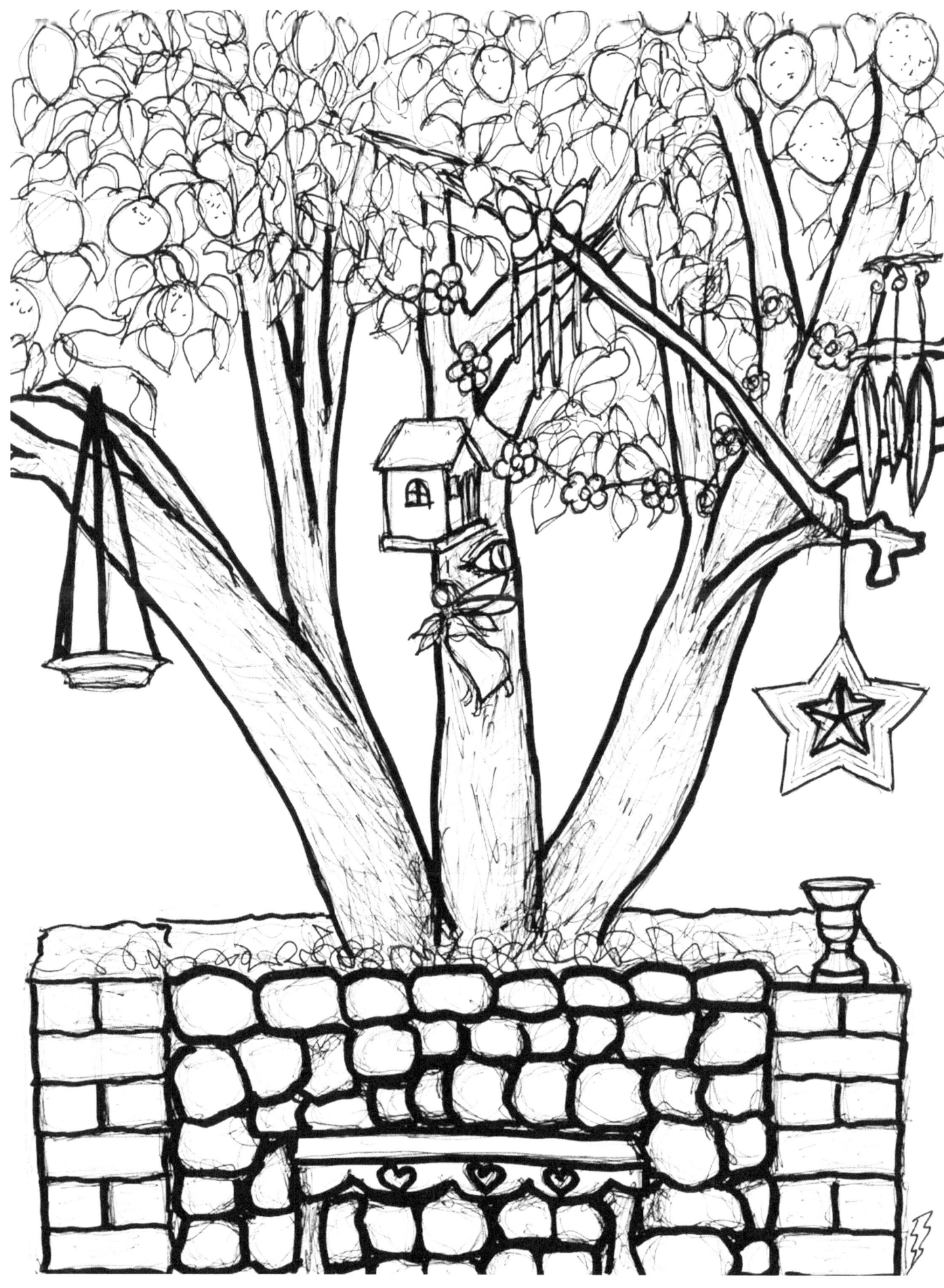

*Have no concern for us trees, dear sister and do not worry and have no fear —

We are here for you, sweet love ~ we want to make this crystal clear!

△For, we are the holders of sacred space for our collective

So you may glow in the light we collect, contain, and radiate!

Please, embrace this truth down into your souls now — breathe in deeply fill with life force — exhale, & emanate!

All is love and all is light the rest is just a dream…

Open your heart & swallow your mind to float in pure love's stream

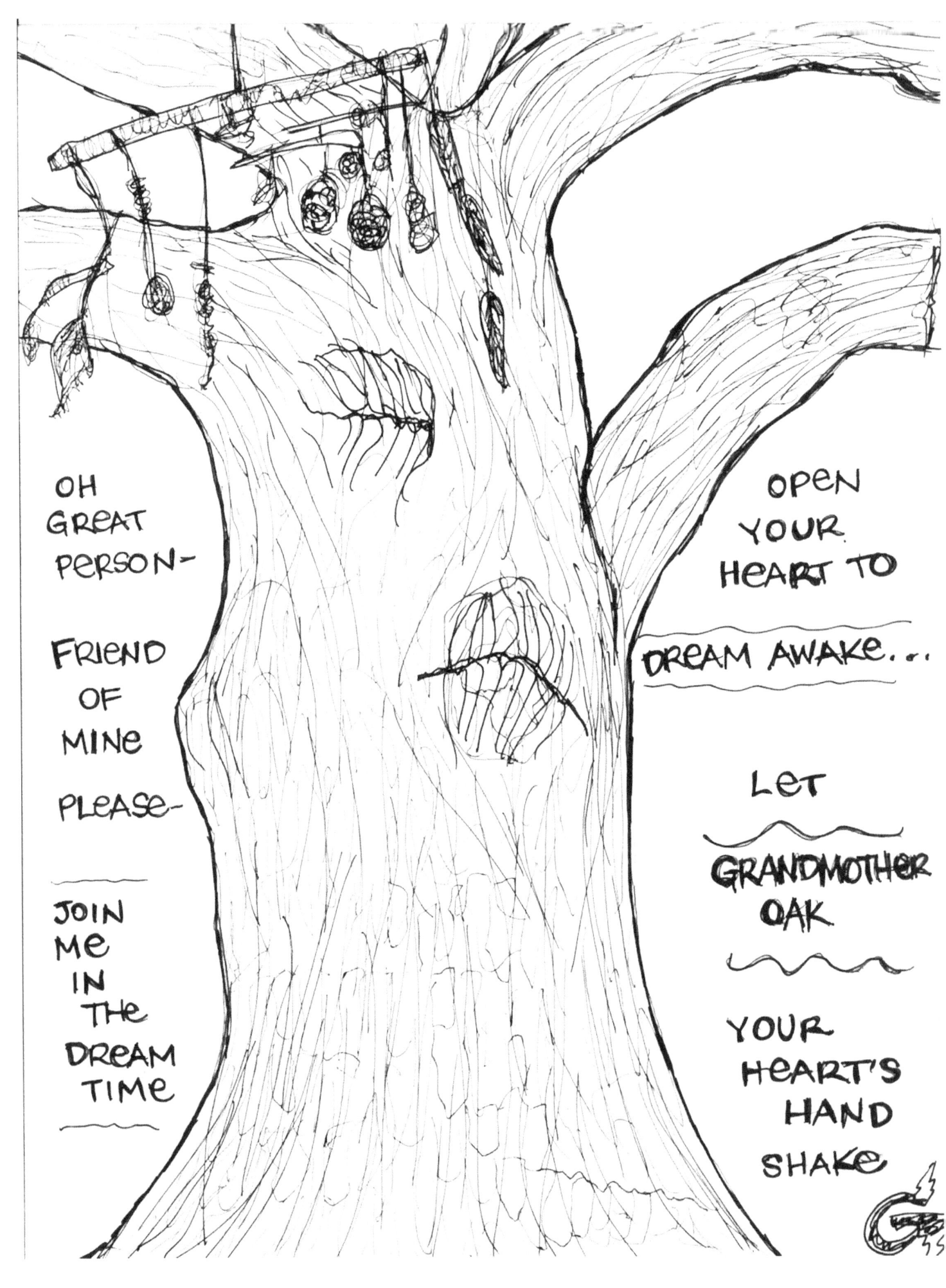

YOU ARE FORGIVEN

BECAUSE LIFE IS BUT A DREAM

I'm HERE TO BRING THE **HEAVEN**

NOW, DRINK MY PRANA, HUMAN BEING!

I USED TO BE A TREE...

AND SO DID YOU— BUT NOW YOU'RE FREE!

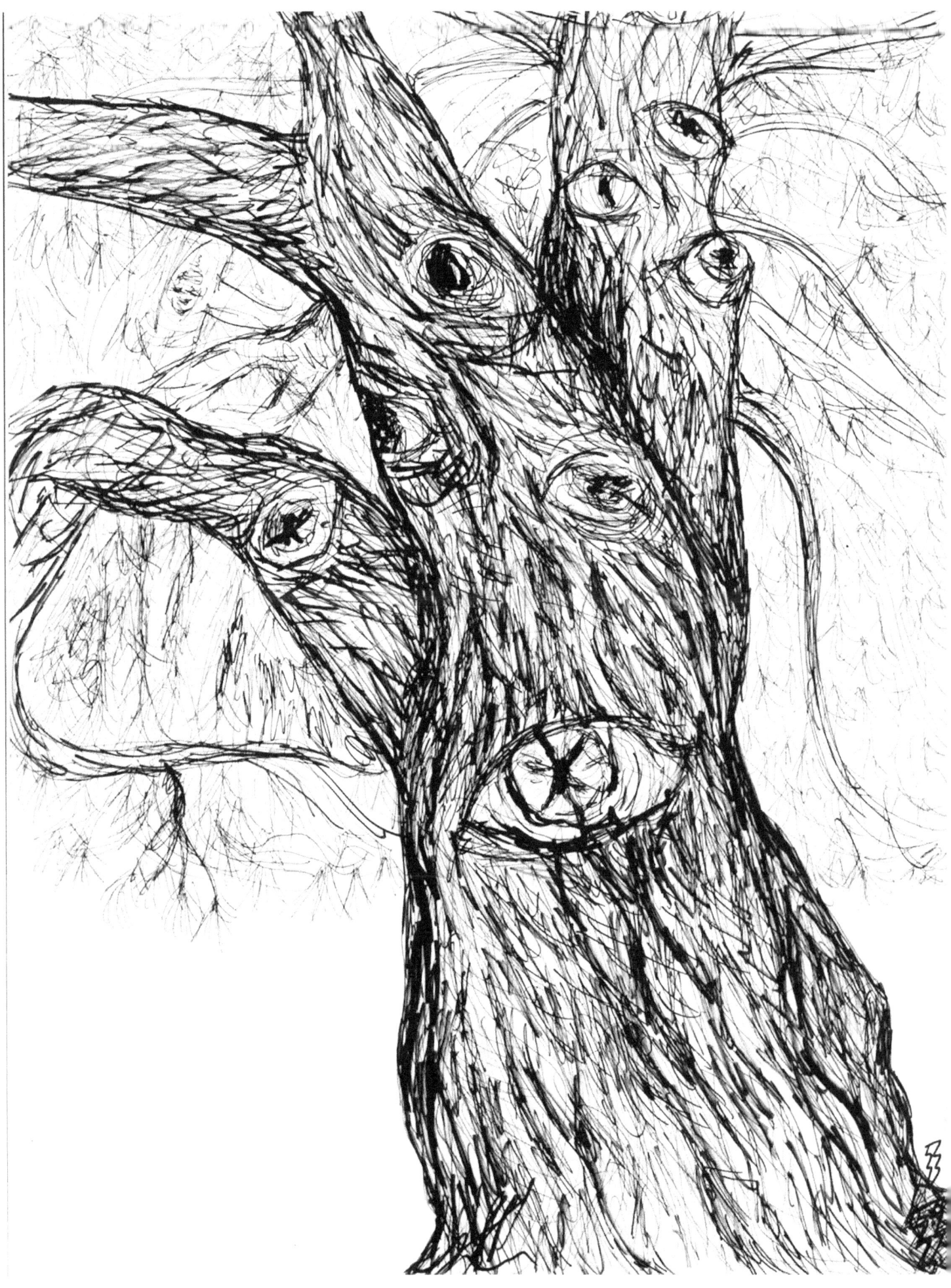

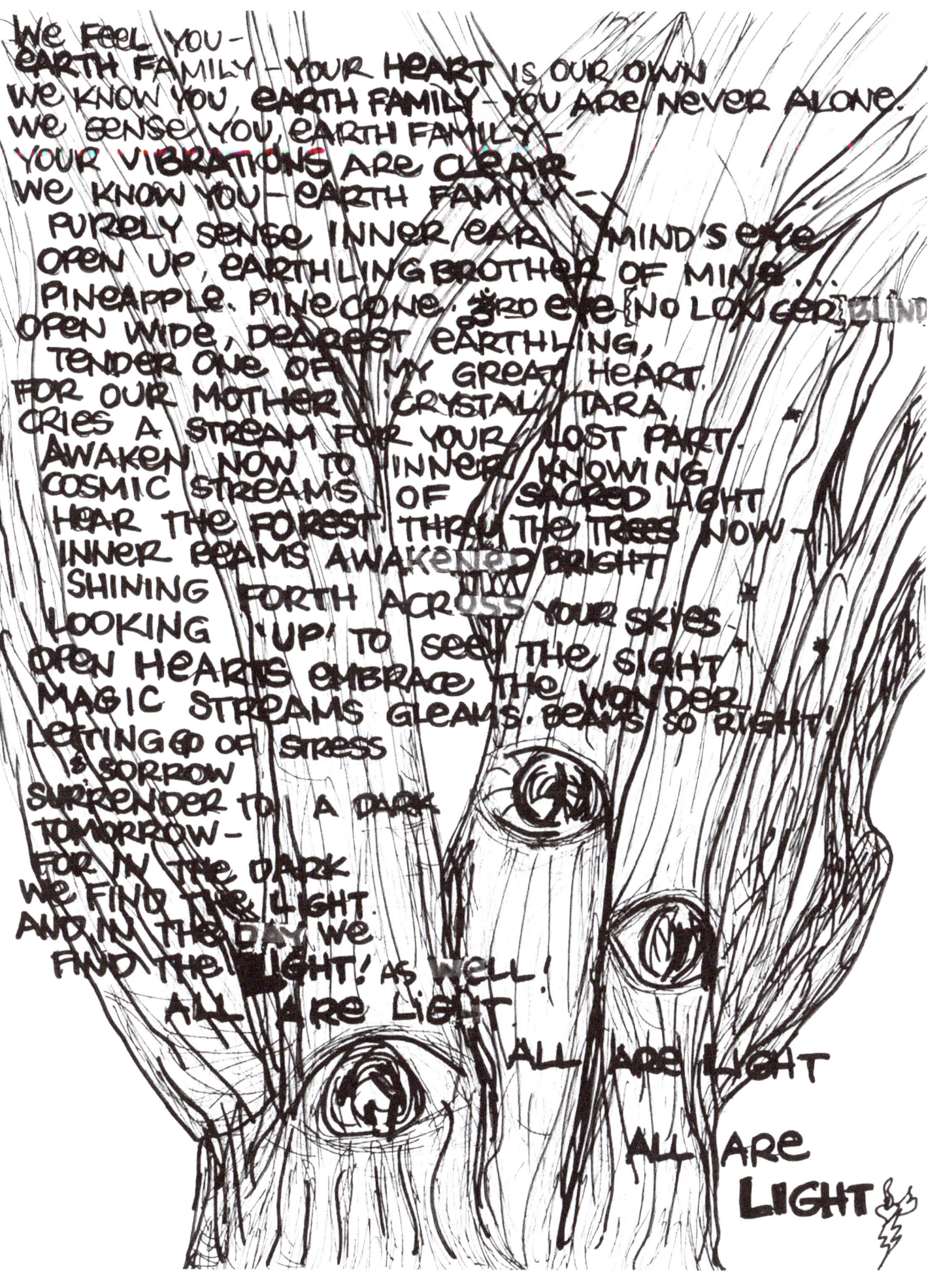

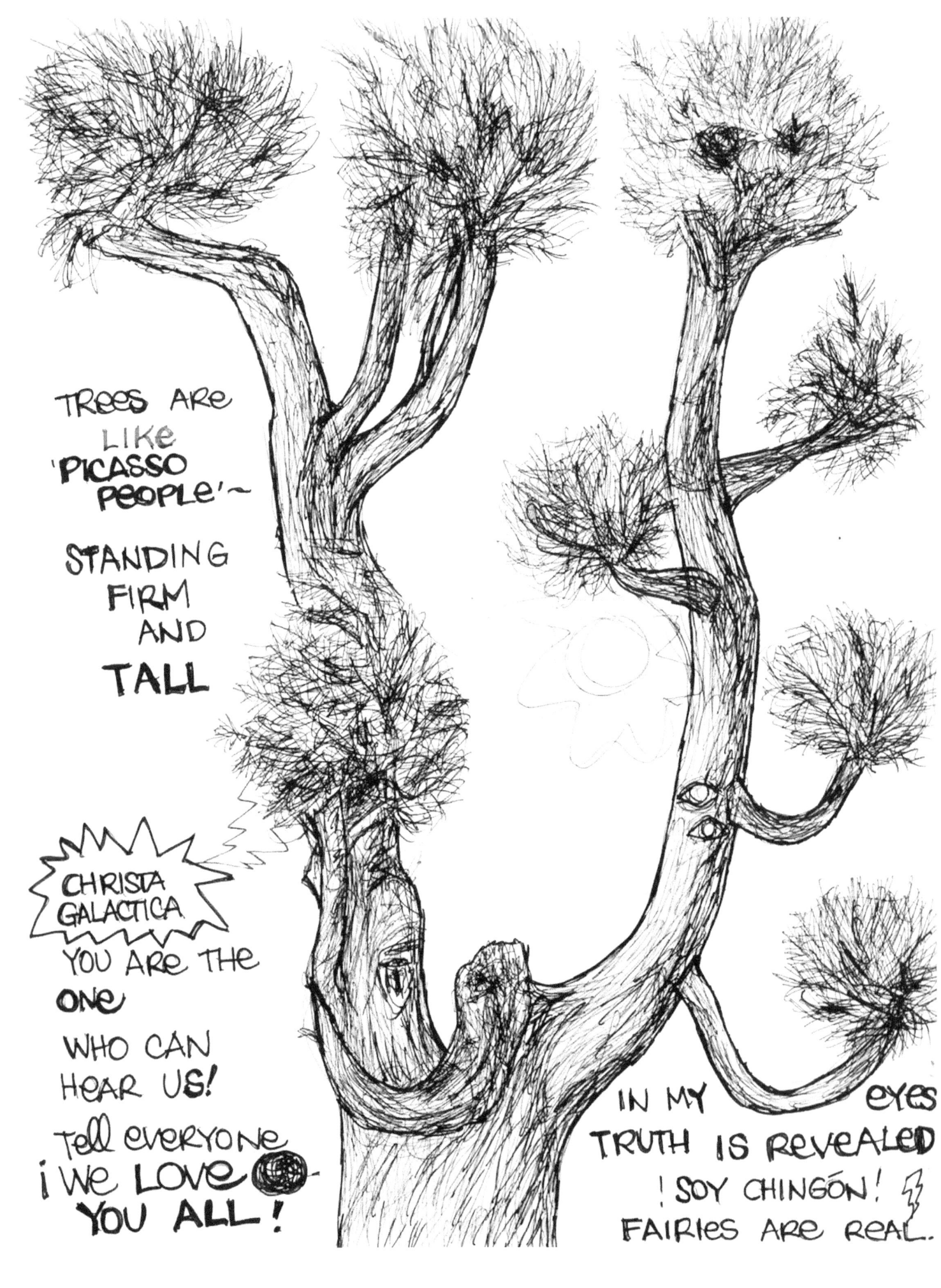

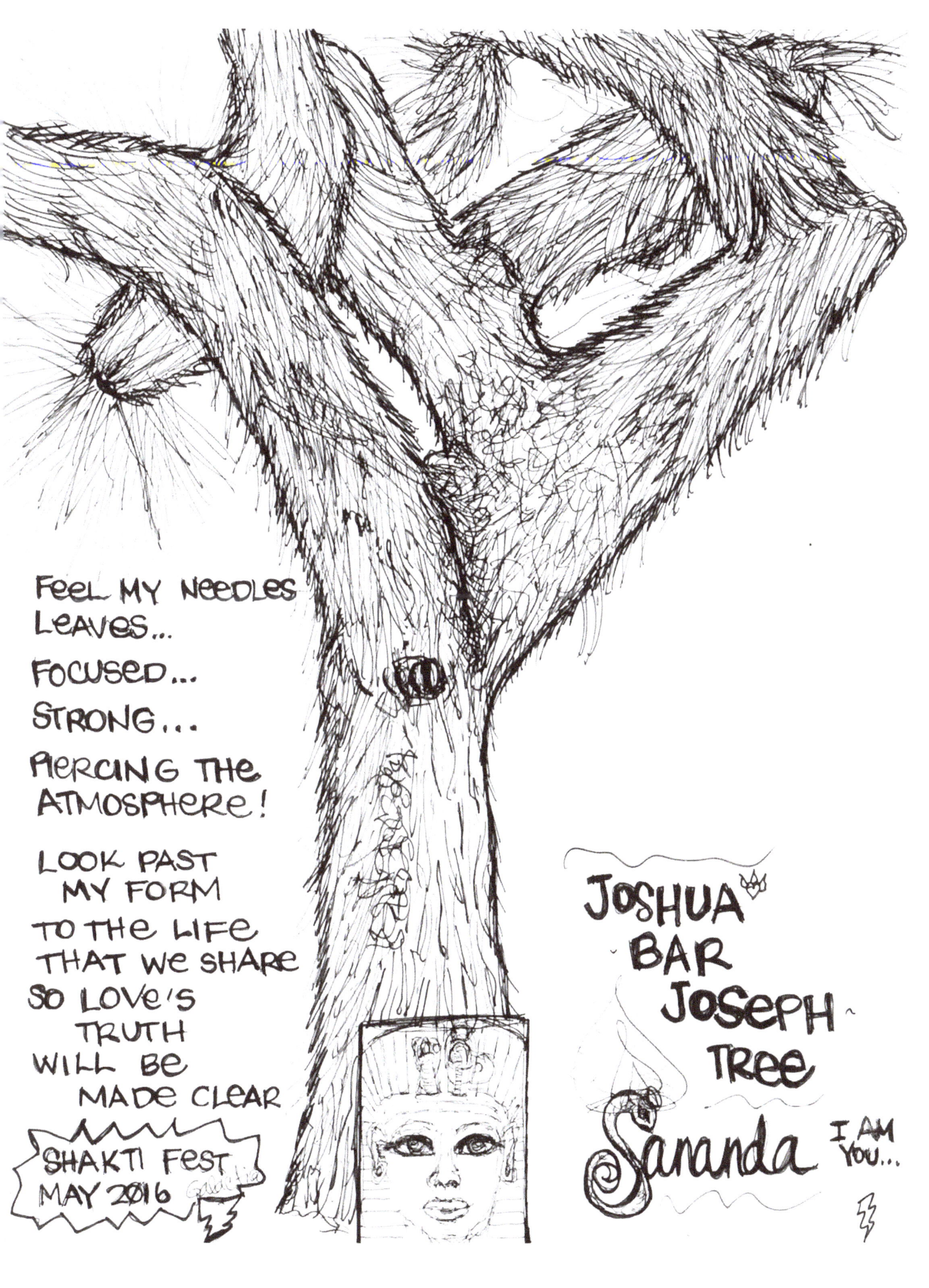

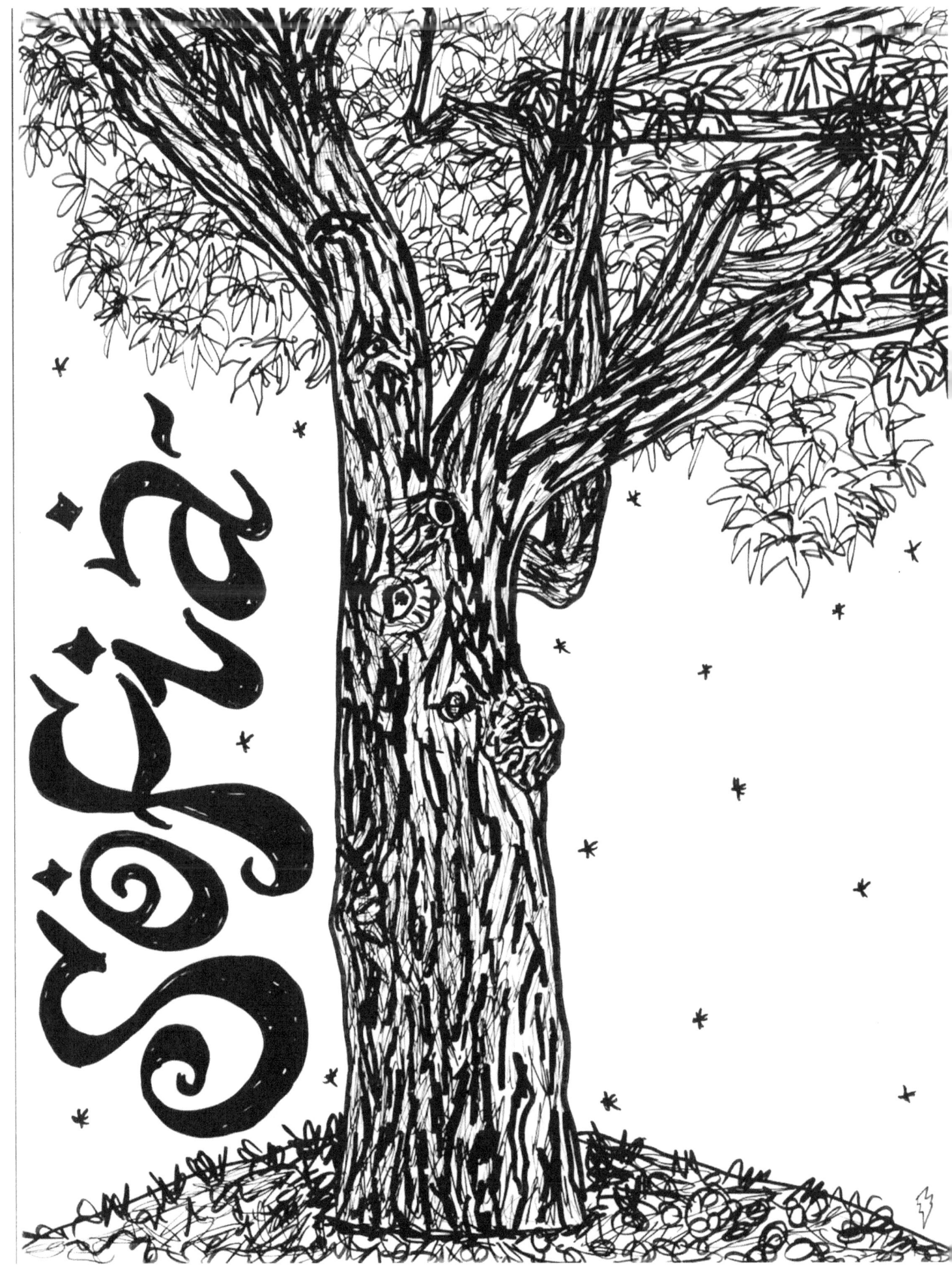

Open your HEART and LISTEN, DEAR ONE
to the WISDOM of the TREE
IF YOU ♥ WISH TO HEAR ITS VOICE
SIMPLY MAKE-BELIEVE
BE STILL & QUIET
 PEACEFUL BRAVE
 EMPTY & ADORING
AND THEN YOU WILL HEAR
 GREAT TREE FRIEND'S SONG ~
 A SPIRIT-HEART-OUT-POURING
FOR, LOVE & TRUTH ARE HEAR & NOW
 WISDOM LIVES WITHIN
AND OUR HEART'S LIGHT
 DOES BEAT AS ONE
 WE ARE ONE ANOTHER'S TWIN
LISTEN TO THIS 'CATTLE CALL' ~
 THIS BEACON BACK TO ONENESS
FOR ONLY IN THIS UNITY WILL YOU DISCOVER FUN-ness
FOR BLISS. EASE. JOY. LAUGHS. HARMONY
 IS THE NATURE OF OUR HEART
LOVE. PEACE. GROWTH. MUSIC. UNITY ~
 WE EACH. ALL ARE OUR PART
WITHOUT EACH BIT THERE COULD BE NO WHOLE ~
 OF THIS WE ARE ALL FACETS
* LIKE STAR. DIAMONDS ~ GLITTER BRIGHT & SHINE
BREATHE IN...
 BREATHE OUT... And that's it!

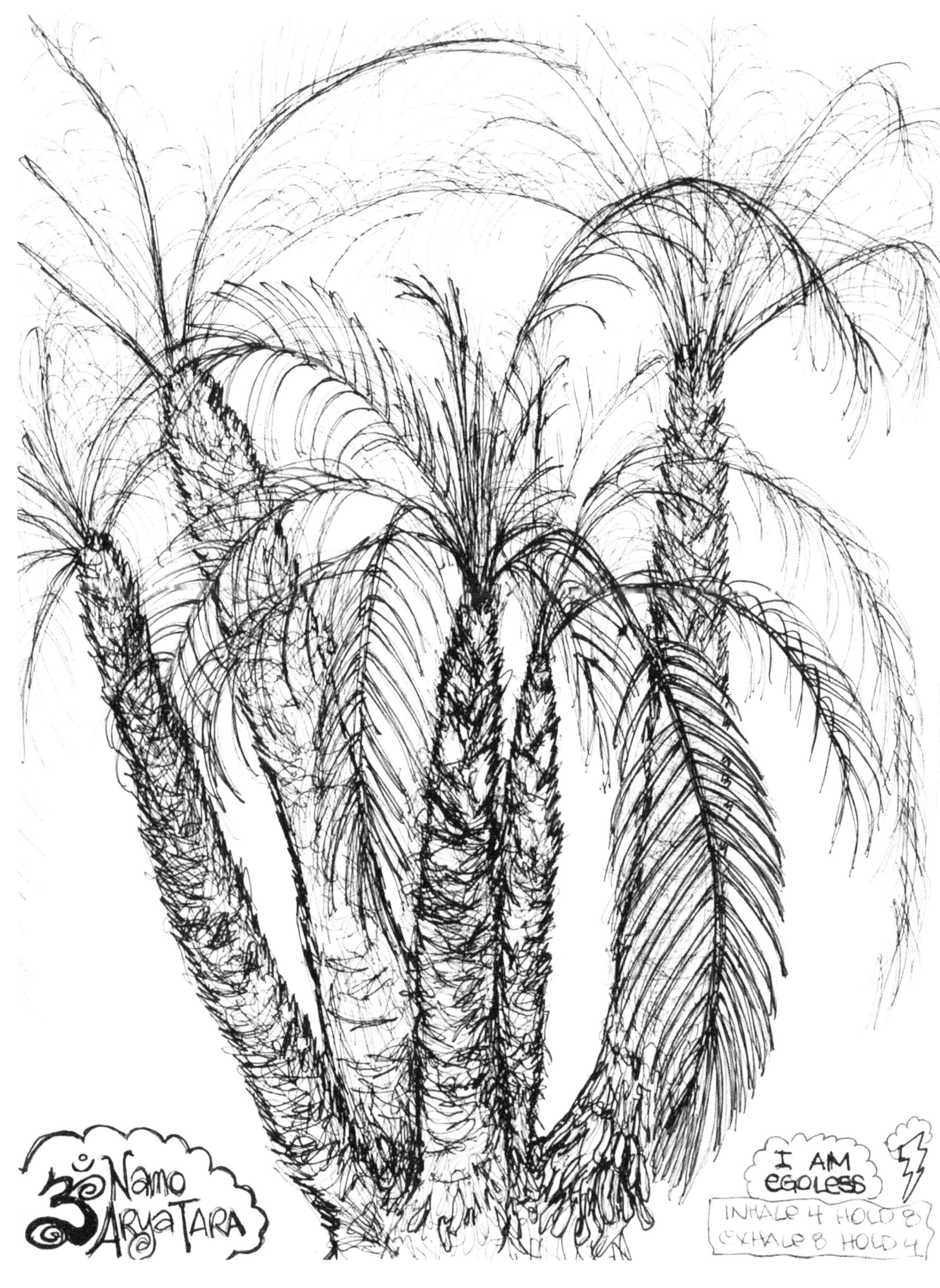

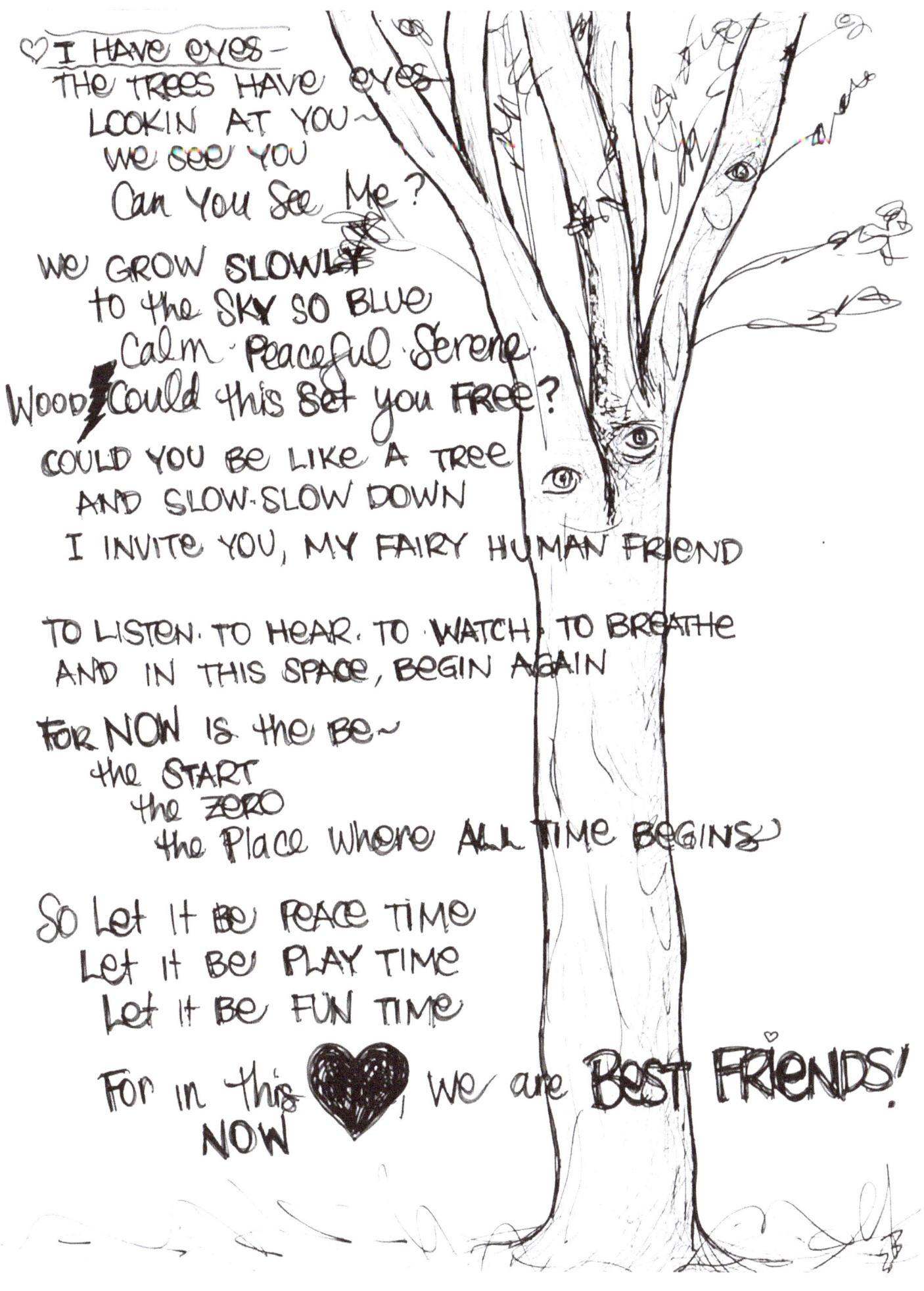

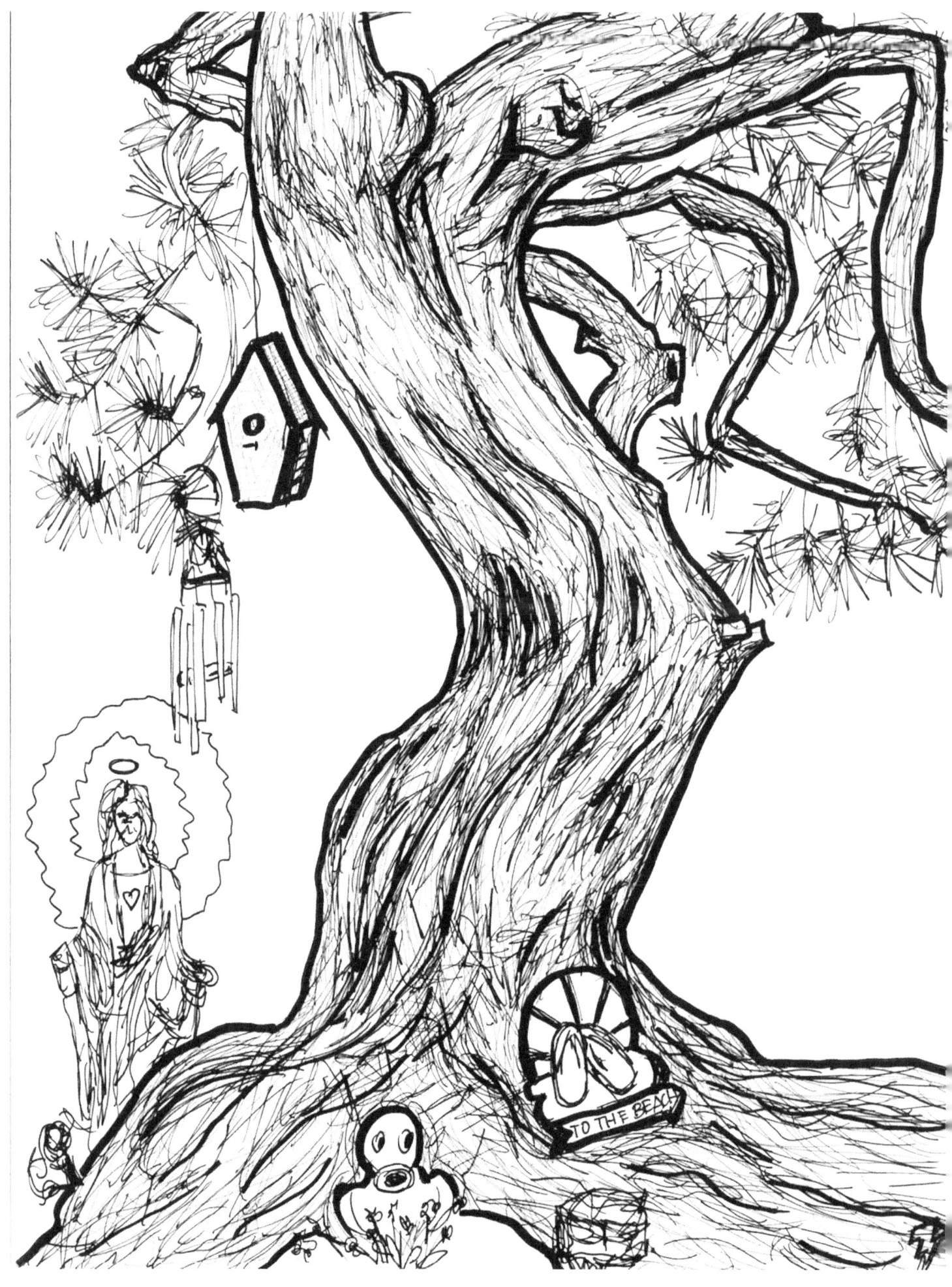

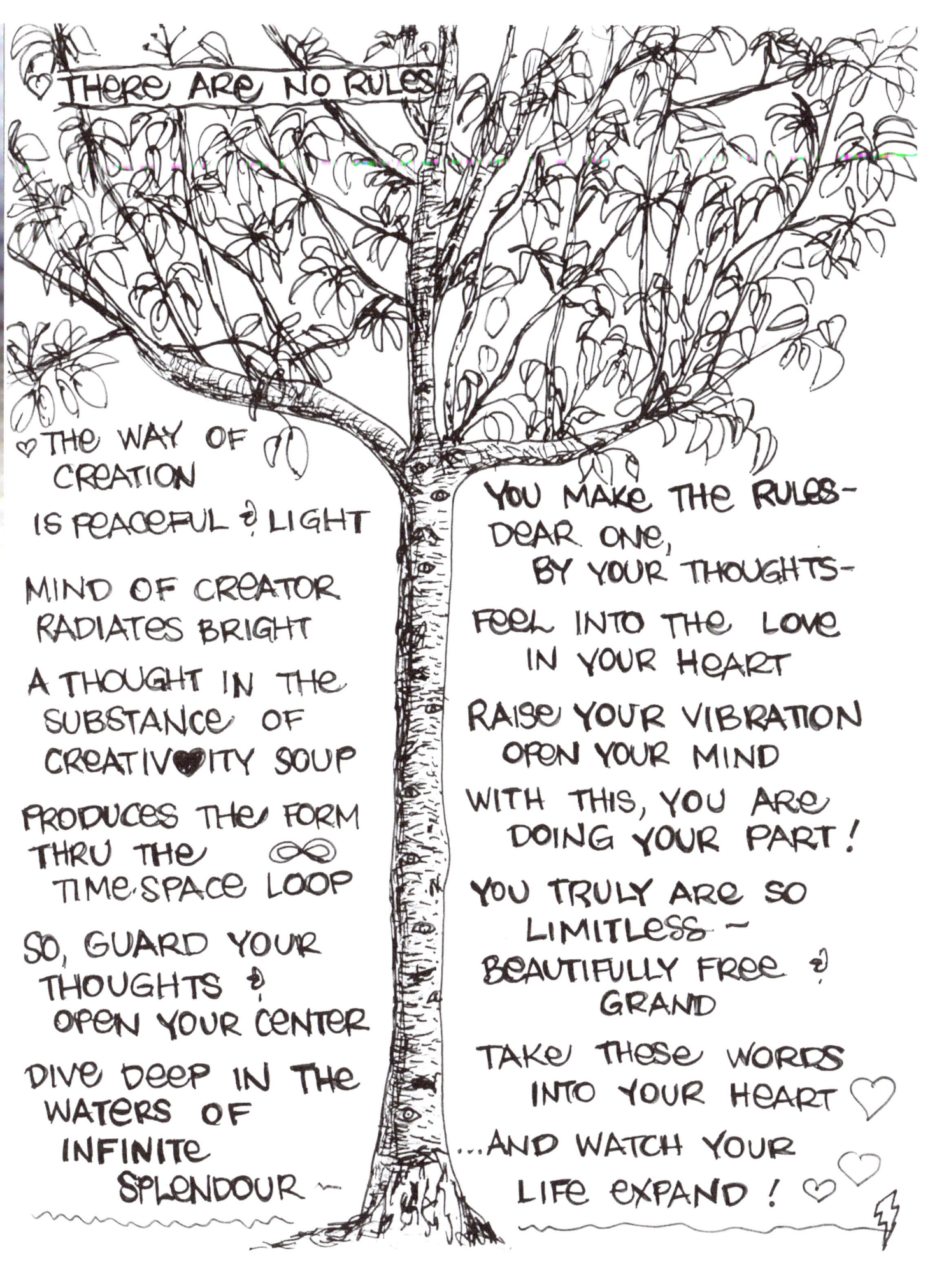

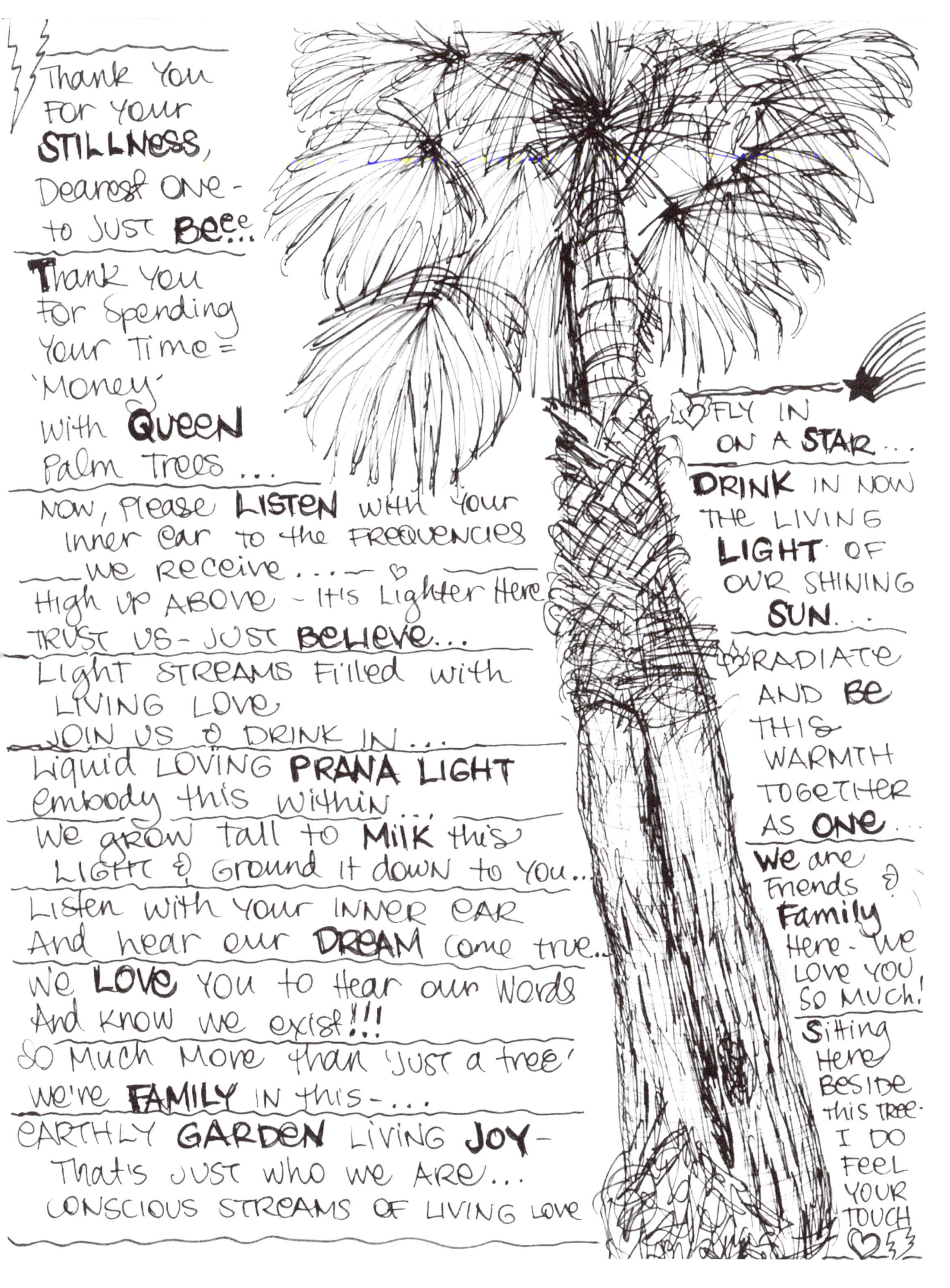

Thank you for your **STILLNESS**, Dearest One - to just **Beee**...

Thank you for Spending Your Time = 'Money' with **Queen** Palm Trees...

Now, please **LISTEN** with your inner ear to the **FREQUENCIES** we receive... ♡
High up ABOVE - it's Lighter Here
TRUST US - JUST **BELIEVE**...
Light streams filled with LIVING LOVE,
JOIN US & DRINK IN...
Liquid LOVING **PRANA LIGHT**
embody this within
We grow tall to **Milk** this LIGHT & Ground it down to you...
Listen with your INNER EAR
And hear our **DREAM** come true...
We **LOVE** You to Hear our Words
And Know We exist!!!
So much more than 'just a tree'
We're **FAMILY** in this -...
EARTHLY **GARDEN** LIVING **JOY** -
That's just who we are...
CONSCIOUS STREAMS OF LIVING LOVE

♡ FLY IN ON A **STAR**...
DRINK IN NOW THE LIVING **LIGHT** OF OUR SHINING **SUN**...
♡ RADIATE AND **BE** THIS WARMTH TOGETHER AS **ONE**...
We are Friends & Family Here - We Love you so much!
Sitting Here Beside this tree. I DO FEEL YOUR TOUCH ♡

♡ I AM A QUEEN ~
I DANCE ON THE
 BREEZE
Which whispers to
 those down below

I HEAR THE SONG
 of the SKY
IN MY INNER eye
Thru my PALMS
I allow it to FLOW...

I stand tall & PROUD
Sure· FOOTED &
 BRAVE
A BEACON of
CALIFORNIAN
 Delights

I AM ROYALTY -
 a QUEEN of this LAND
for a REASON

I am GUARDIAN
 of LIGHT
and I GLOW ♥!

SO,
 LISTEN -
 TUNE IN -
My Dear
 HUMAN
 FRIEND -
to the Song
 of the LIGHT
 on the WIND

And YOU WILL
 TRANSFORM
as easy as PIE -
 in the SKY
and BEGIN
 once AGAIN

BEGIN to BE ~~FREE~~...
and to see you're
 LIKE ME -
Rooted & Grounded
 & tall
GROWIN & GLOWING
WAVING & SHINING

Reminding ALL
 LIFE
 JUST to BE...

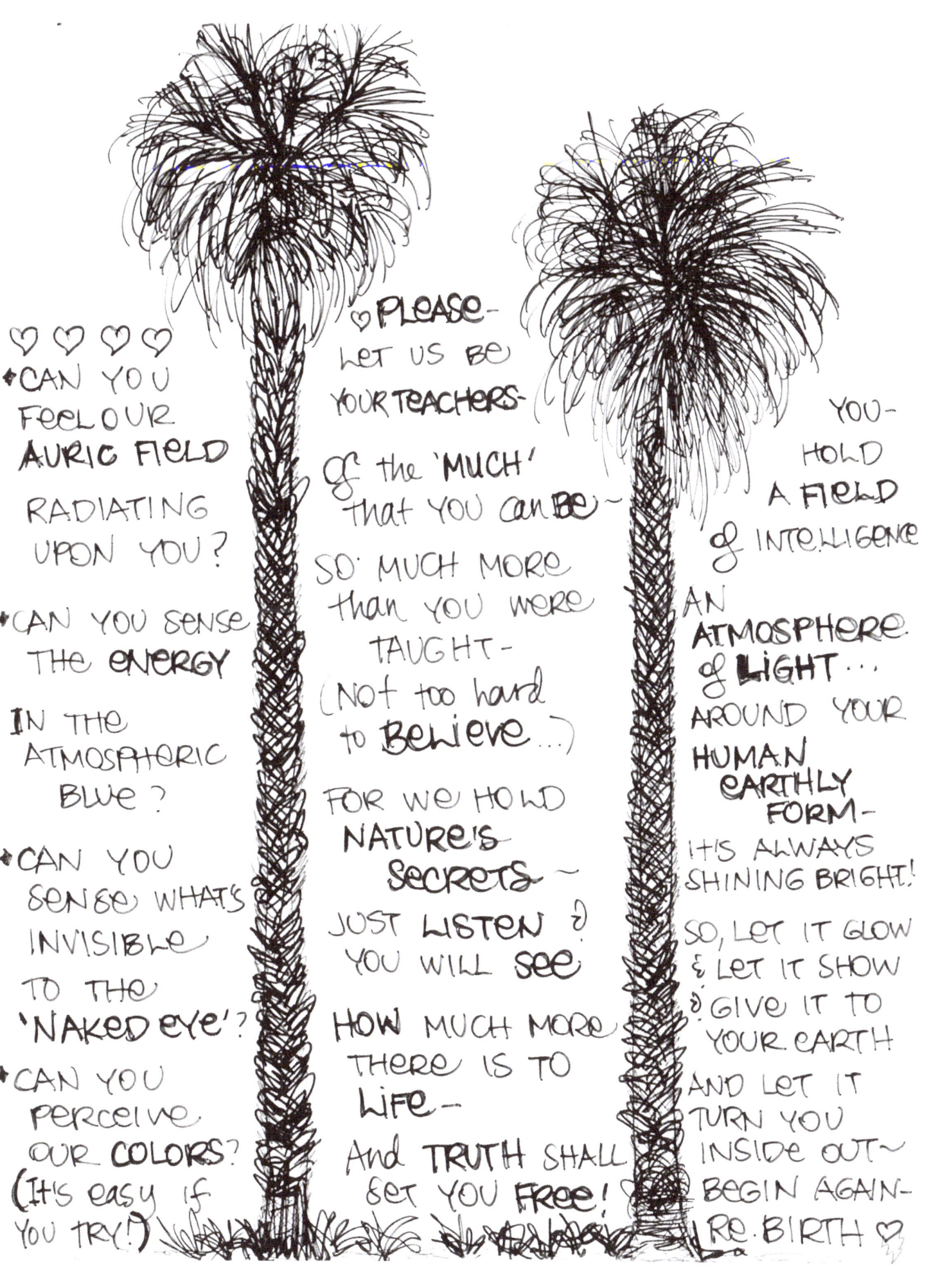

♡♡♡♡
- CAN YOU FEEL OUR AURIC FIELD RADIATING UPON YOU?
- CAN YOU SENSE THE ENERGY IN THE ATMOSPHERIC BLUE?
- CAN YOU SENSE WHAT'S INVISIBLE TO THE 'NAKED EYE'?
- CAN YOU PERCEIVE OUR COLORS? (It's easy if you try!)

♡ PLEASE - LET US BE YOUR TEACHERS - of the 'MUCH' that YOU can be ~ SO MUCH MORE than YOU were TAUGHT - (Not too hard to BELIEVE...) FOR WE HOLD NATURE'S SECRETS ~ JUST LISTEN & YOU WILL SEE HOW MUCH MORE THERE IS TO LIFE - And TRUTH SHALL SET YOU FREE!

YOU - HOLD A FIELD of INTELLIGENCE AN ATMOSPHERE of LIGHT... AROUND YOUR HUMAN EARTHLY FORM - IT'S ALWAYS SHINING BRIGHT! SO, LET IT GLOW & LET IT SHOW & GIVE IT TO YOUR EARTH AND LET IT TURN YOU INSIDE OUT ~ BEGIN AGAIN - RE-BIRTH ♡

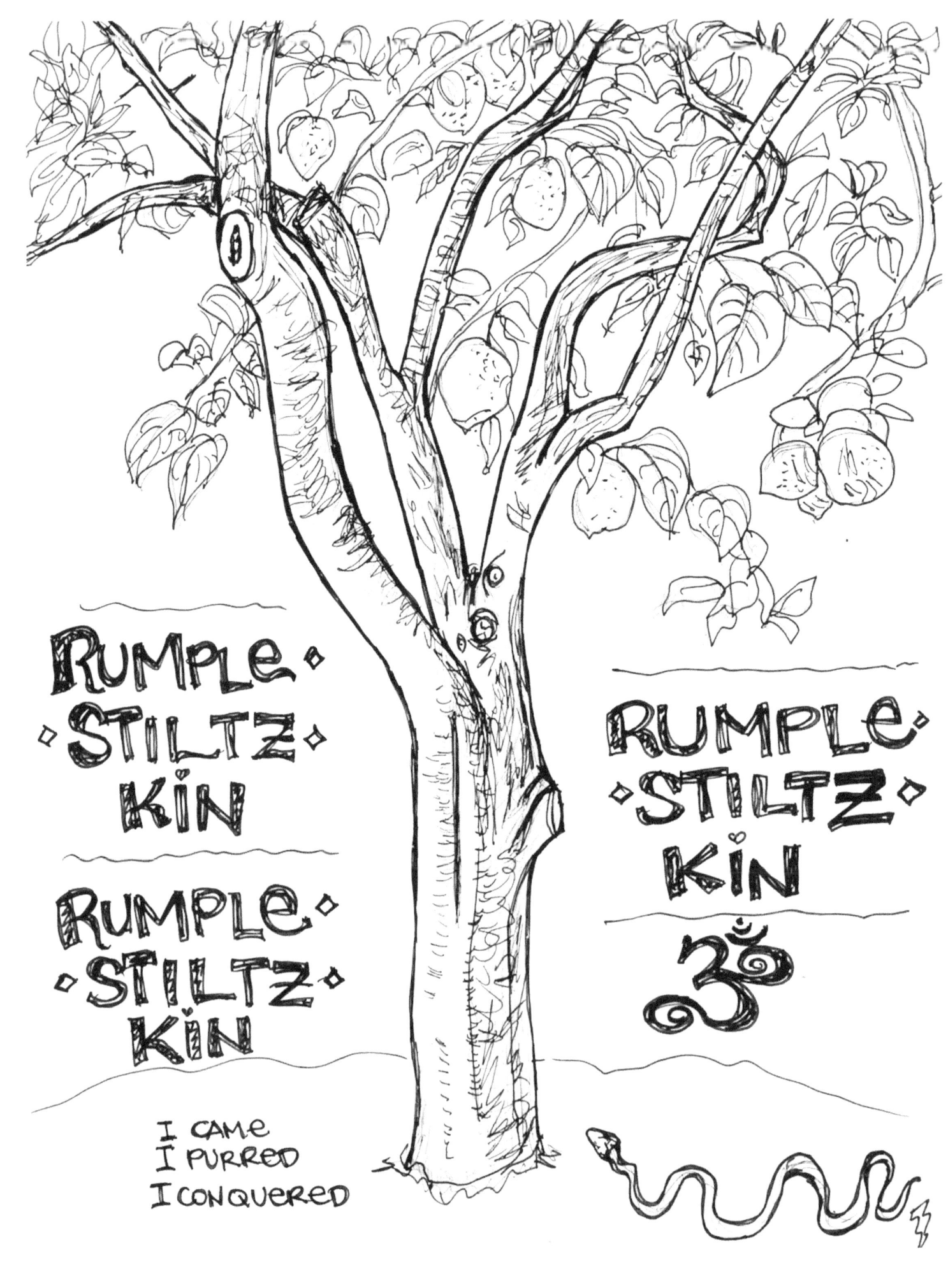

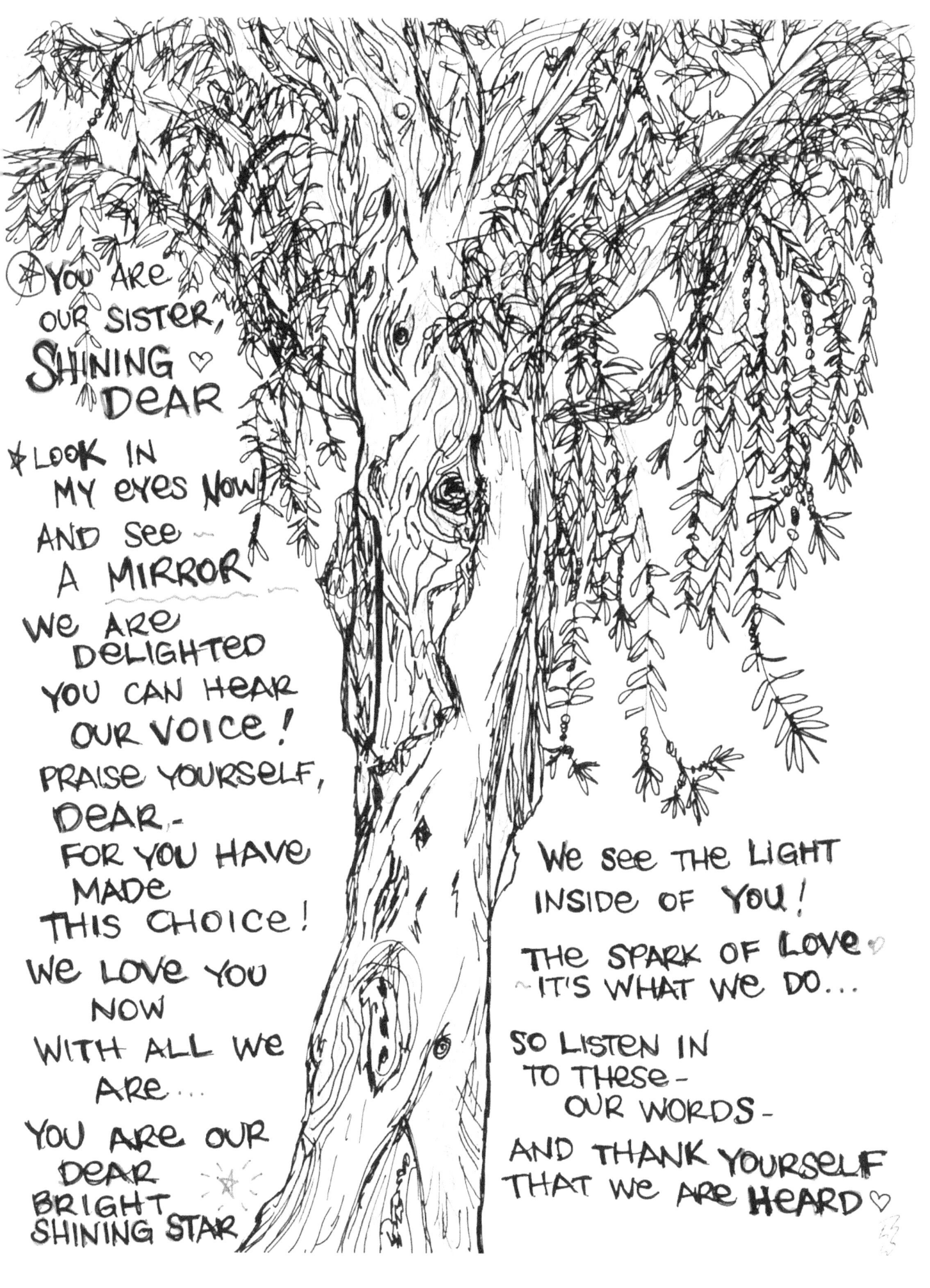

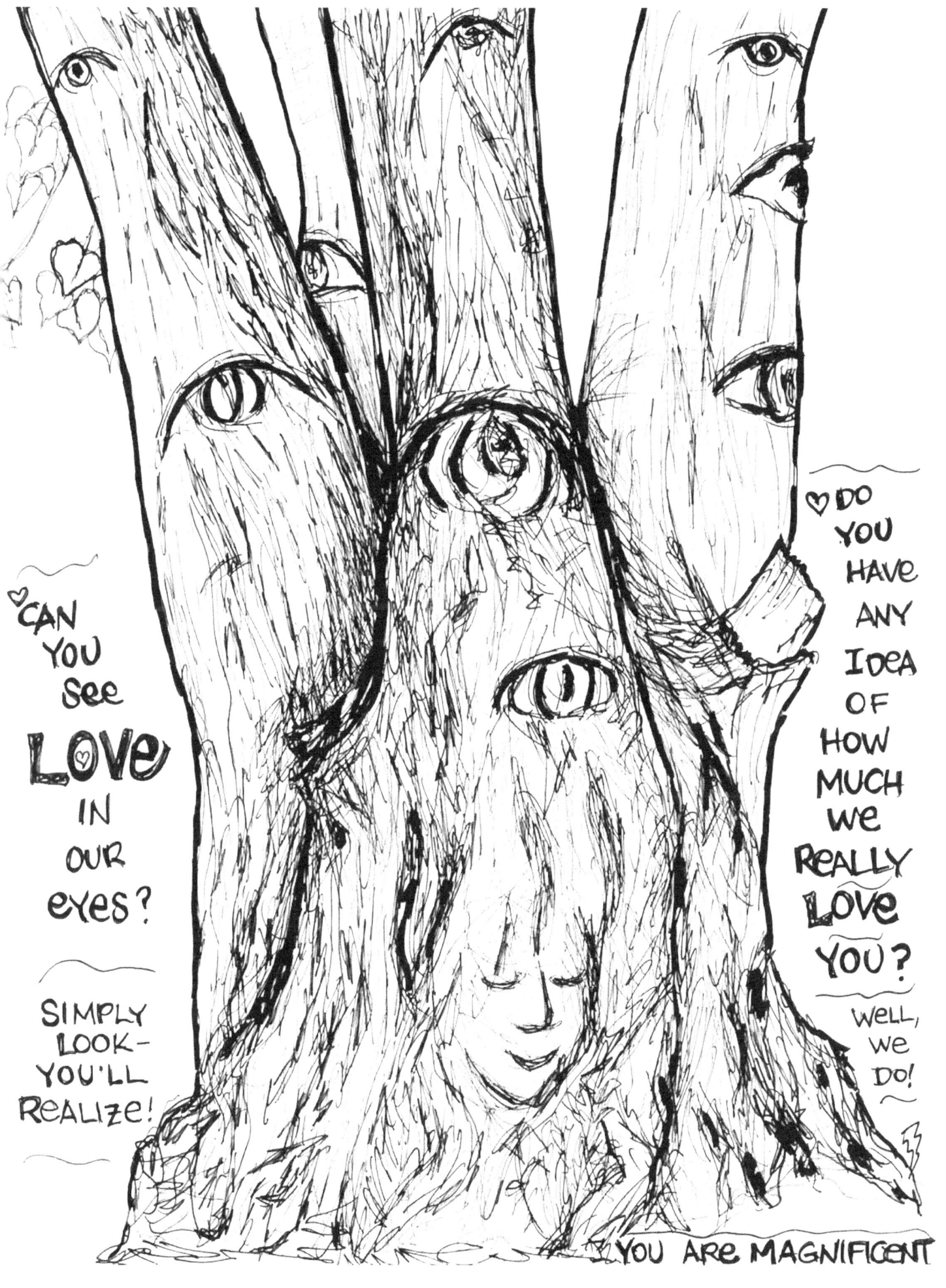

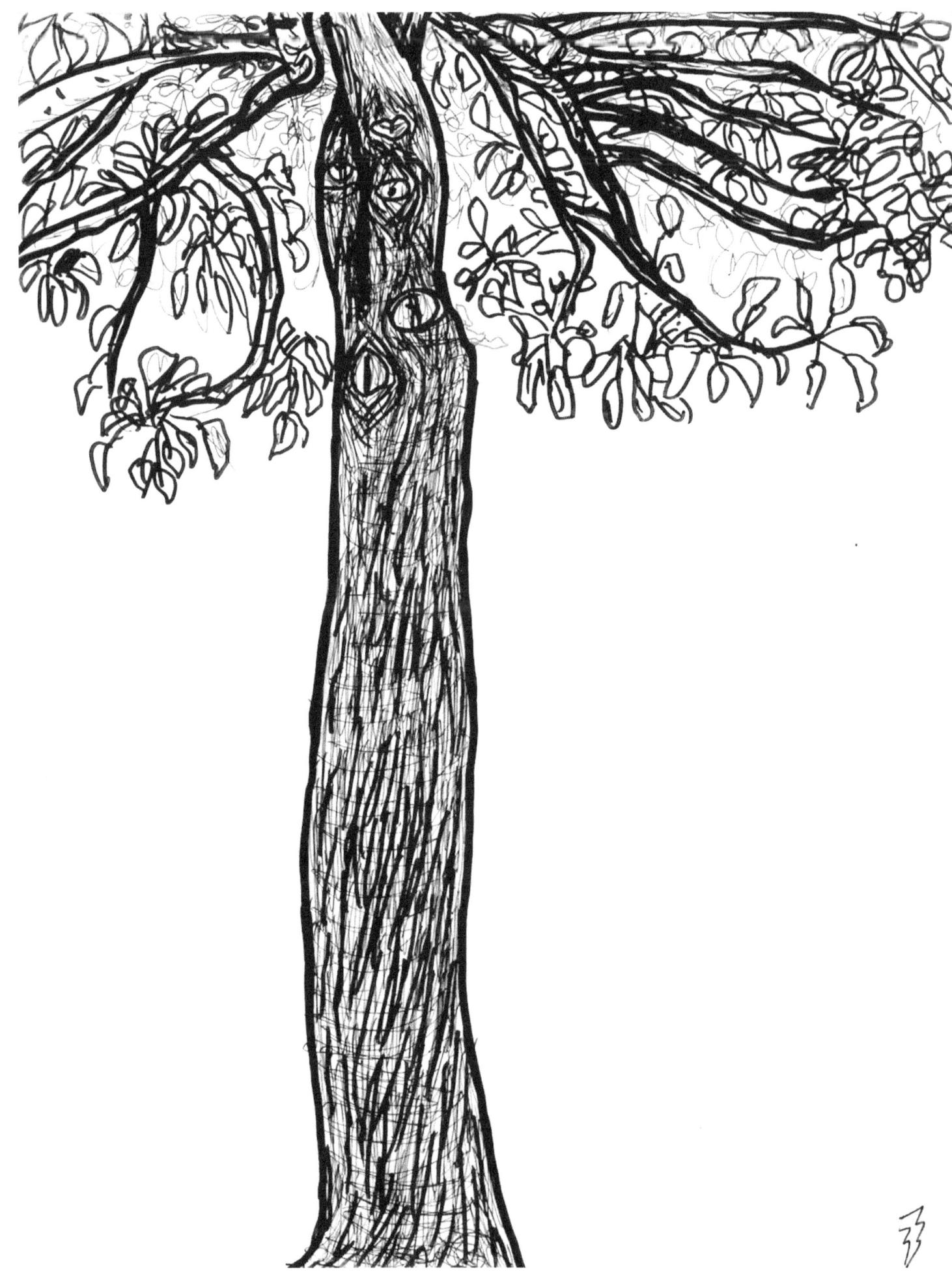

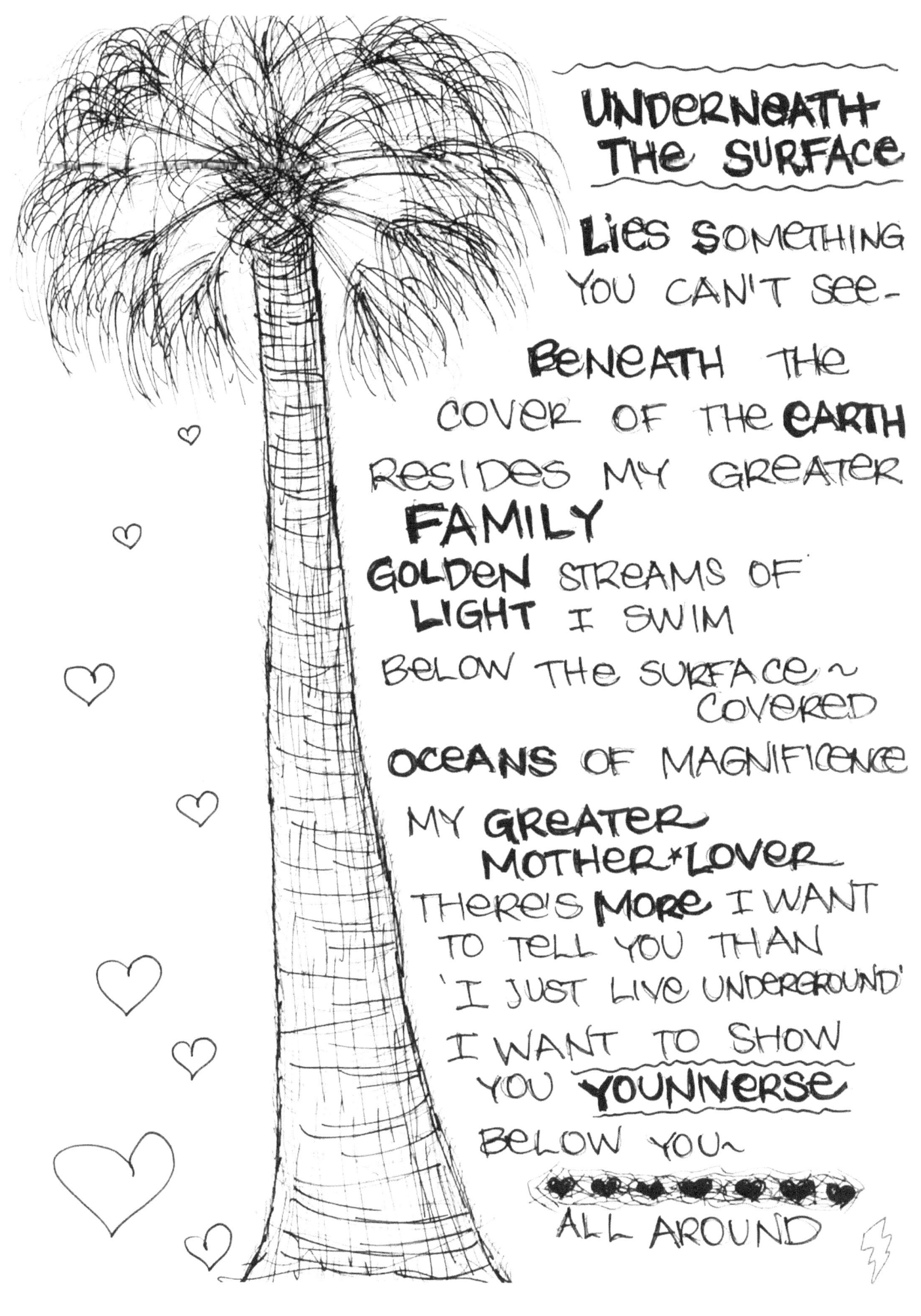

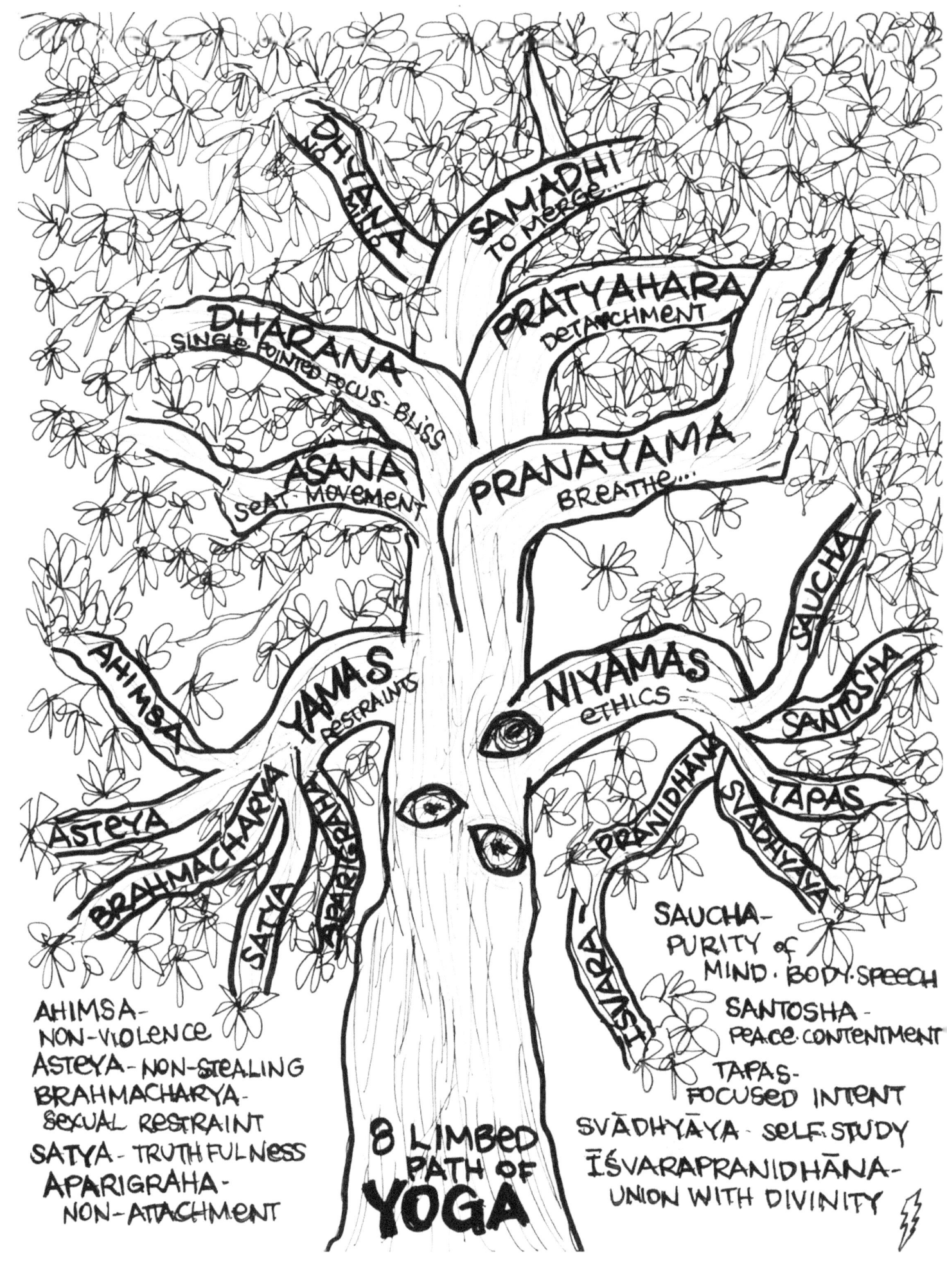

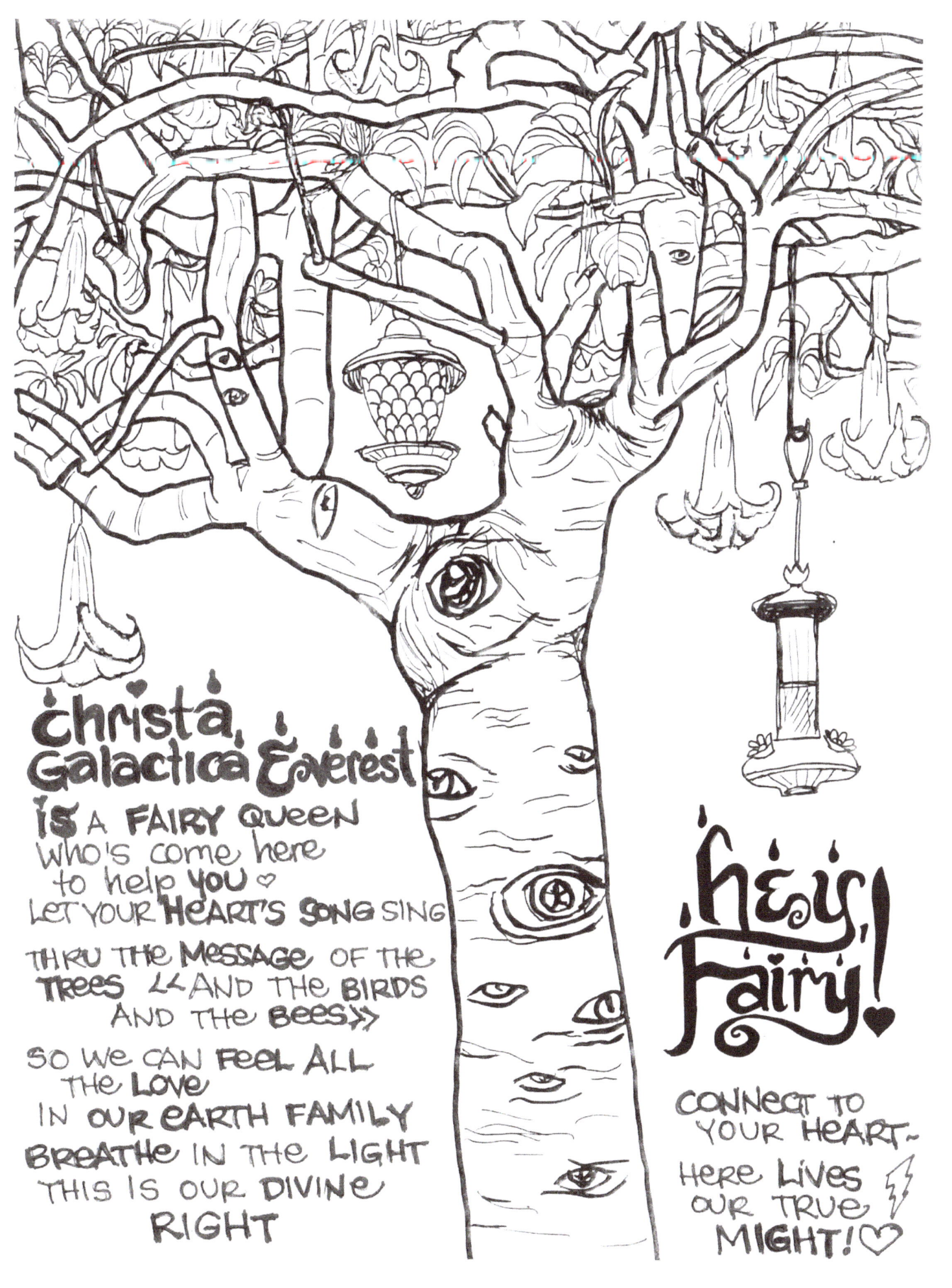

www.ingramcontent.com/pod-product-compliance
Lightning Source LLC
Chambersburg PA
CBHW080550190526
45169CB00007B/2718